BERYL COOK

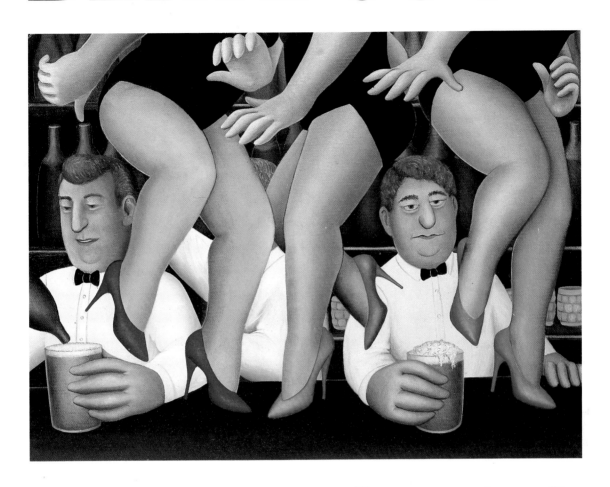

BOUNCERS

VICTOR GOLLANCZ

LONDON

other books of paintings
by Beryl Cook

THE WORKS

PRIVATE VIEW

ONE MAN SHOW

BERYL COOK'S NEW YORK

BERYL COOK'S LONDON

First published in Great Britain 1991
by Victor Gollancz Ltd

First Gollancz Paperback edition published 1993
by Victor Gollancz
A Cassell imprint
Villiers House, 41/47 Strand, London WC2N 5JE

© Beryl Cook 1991
Introduction © Joe Whitlock Blundell 1991

A catalogue record for this book
is available from the British Library

ISBN 0 575 05656 8

Printed and Bound in Italy by
Amilcare Pizzi s.p.a.

Summertime!

Painters from the Portal Gallery

York City Art Gallery

2 July - 4 September 1994

Beryl Cook
Meadow Suite

Summertime!

Painters from the Portal Gallery

York City Art Gallery
2 July - 4 September 1994

Terry Clark
Bandit in the Sky

P. J. Crook
Fishing round the Lighthouse

The remarkable observation and imagination of artists such as Beryl Cook, James Lloyd, Reg Cartwright and P. J. Crook bring a bright, colourful and relaxed summer into York City Art Gallery.

Fat ladies, lazy-day gardening, games, fairs, carnivals, fantastic boats and planes in summer skies, and other weird and wonderful summer images provide a humorous and quirky celebration of summertime.

The Portal Gallery, London, which opened in 1959, represents the finest and most idiosyncratic British artists.

The Gallery is open Monday-Saturday 10-5; Sunday 2.30-5; last admission each day is at 4.30.

Admission £1.25, concessions 75p (children, students, OAPs, UB40s and Friends of York Art Gallery), family ticket £3.50; city residents with York Card free.

York City Art Gallery
Exhibition Square
York YO1 2EW
Telephone: (0904) 623839

Exhibition organized by York City Art Gallery and the Portal Gallery, London

City of York Leisure Services

BERYL Frances Lansley was born sometime between the two World Wars, in Egham, Surrey, the third of four daughters – Cynthia, Mary, Beryl and Freda. After moving to Reading, Beryl left school at the age of fourteen without having displayed much promise in the art class and went to work in an insurance office.

In 1943 the family moved to London and Beryl began her short stage career, working as a show girl in a touring production of 'The Gipsy Princess'. She next became a model for a number of dress firms, developing a life-long fascination with the way we dress and make ourselves up, and how the reality often fails to live up to our intentions.

Three years later Beryl left London and with her mother and Freda bought a house and tea-garden on the river at Hampton. It was there that she married John Cook, who had lived next door to them in Reading. At the reception they had the misfortune of both falling into the River Thames. John was an officer in the Merchant Navy and for the next eight years he and Beryl saw little of each other. In 1956 they decided that a bit more family life was in order, so John retired from the sea and they moved with their son John (then aged six) to Stoke-by-Nayland where they managed a pub. They found that rural life, even in the heart of Constable country, did not suit them and the following year John took a job with a motor company in Southern Rhodesia. It was there that Beryl – who worked in turn for a firm which built bus bodies, a wholesale fruiterers, an office equipment suppliers and an insurance brokers – started to paint. Showing their son how to use his box of watercolours she had been surprised at the pleasure it gave her; John bought her a child's oil-painting set for her birthday and with it she produced her first significant work, a half-length portrait of a dark-skinned lady with a somewhat vacant expression and large drooping breasts. John, unkindly but aptly, named it 'Hangover', and to this day the painting hangs in their house in Plymouth.

In 1963 John was transferred by his company to Zambia but shortly afterwards they decided to return to England, since he had heard of a promising job in Bodmin. They took to Cornwall at once and settled in a cottage on the harbour-front at Looe. The bare rooms worried Beryl, so she resolved to cover the walls with pictures and began painting in earnest. Not being very well off, and feeling that her art did not justify lavish expenditure, she painted on any materials that came to hand: driftwood from the beach, offcuts from the timber merchant, or any odd pieces of wood John found at the garage where he worked. Despite the greater difficulty of painting on wood, Beryl became accustomed to the medium and, with rare exceptions, has stuck to it ever since, though now the flotsam and jetsam has been replaced by neatly cut sheets of

plywood from the timber merchant.

After five years in Looe the Cooks moved to Plymouth where, during the summer months, Beryl ran a boarding-house for holidaymakers on the Hoe. This left no time for painting, which was reserved for the winter, but gave her great opportunities to observe humanity at close quarters; many of her summer visitors unwittingly found their way into her paintings the following winter. Another lasting source of material was her favourite public house, the Lockyer Tavern. Many blissful hours were spent watching the dancing, singing and drag acts, which were later recorded by Beryl's meticulous brush. This Gay bar closed down some years ago, but others have taken its place and are favourite sources of entertainment on Friday and Saturday nights and provide subjects for her paintings during the week.

For several years Beryl continued to paint with no other thought than to cover the walls of her home, though after a time there were so many pictures that she piled them in cupboards, in corners, anywhere to get them out of the way. Eventually, in 1975, an antique-dealer friend persuaded her to let him take away a dozen or so and try to sell them. Within a few days he had sold all of them for around £30 each, which so delighted Beryl that she rapidly painted a whole new batch, despite it being the height of the holiday season. Bernard Samuels of the Plymouth Arts Centre heard of this local prodigy and, overcoming her considerable resistance, persuaded her to put on a show of seventy-five paintings.

From then on Beryl Cook's fame grew with astonishing speed. An article appeared in the *Sunday Times* Colour Magazine which led to exhibitions at the Whitechapel and Portal Galleries in London, the Alexander Gallery in Bristol and the Cahors Museum in France, and to the publication in 1978 of her first book of paintings, *The Works*. At the same time her paintings were reproduced as greetings cards and as limited edition prints and soon her work was seen in newspapers and magazines around the world, her quintessentially English images tickling ribs from Kingston to the Cape.

Popular acclaim has been accompanied by serious critical appreciation, manifested most notably by the inclusion of her paintings in the fifth Peter Moores exhibition at the Walker Art Gallery in Liverpool. Here she was seen in the context of mainstream contemporary art, alongside Bridget Riley and Victor Pasmore.

Fame has scarcely interfered with Beryl Cook's family life. She and John still live on Plymouth Hoe in a fine house filled with an extraordinary collection of colourful bric-a-brac, from which she sallies forth each morning to do the shopping before settling to the easel. She is now – astonishingly – a great-grandmother twice over. She no longer takes in

boarders but works all the year round, even when journeying abroad, to Hollywood and New Orleans, Barcelona and Venice, Hamburg and Paris, or travelling within Britain, where ports and coastal resorts such as Liverpool, Brighton and Southsea are among her favourite beauty spots.

All these places appear in the paintings, and many within the pages of this book. She likens her work to a visual diary, always reflecting the immediate circumstances of her life, whether it be staying up late in a bar in Union Street frequented by sailors and their girls, watching the comings and goings in the red-light district of Marseilles, or just sitting at home watching her pets play on a rug. Indeed cats and dogs often invade her paintings, but rarely without human company, for it is human life which interests Beryl above all: she is a passionate observer of all our goings-on and she depicts us with a rare combination of humour and understanding.

Beryl Cook's work has been compared with that of almost any other artist who liked painting big bodies (Rubens included) or who had an essentially humorous view of life: but apart from Stanley Spencer, Donald McGill and Edward Burra, whose work she reveres, it is hard to trace any direct influences on her painting. She certainly does not belong to the 'naive' school whose work is characterised by an appearance of innocence either real or contrived; Beryl's work is too worldly and too natural. Yet it is sophisticated in a completely individual way which bears scant resemblance to any contemporary artistic trend. But such trends are of less importance in our final assessment of her work than contemporary life itself, of which Beryl's paintings are so faithful and fascinating a mirror.

JOE WHITLOCK BLUNDELL

GARE DU NORD

I had bought a pair of shoes from a flea-market in Plymouth and they were so attractive I knew I would not rest until I had painted them. On visits to Paris I've seen quite a few middle-aged and old ladies wearing rather eccentric clothes so I thought this would be a good place to show them off. We had arrived at the Gare du Nord early in the morning while travelling from Milan and I saw the young couple kissing as we sat down for coffee. The customer at the next table was the owner of the loaf of bread in the knapsack, but the croissants were all painted from one I bought here and turned round and round to show the different views. I had to do a lot of drawings before I came up with someone suitable for the shoes and I finally decided that this one would be satisfactory, and rather French.

GIRLS IN A TAXI *(on following pages)*

Here are some girls getting a lift to the next port of call, a nightclub, I expect. They certainly enjoy themselves when they are out together going from pub to pub, sometimes pausing to sing and clap if a suitable record is playing. A manageress told us once that she didn't allow 'Nelly the Elephant' to be played any longer, that it made the fellows turn funny and do peculiar things. I was sorry that she'd banned it before I'd seen just what happened. The taxis wait for custom outside Colonel Sanders' Kentucky Fried Chicken emporium, which is handy for a take-away supper. Whilst waiting for his chicken to be fried my husband asked the assistant if she'd seen the Colonel lately. She told him no – she'd only been there two weeks. I seem to be rather fond of taxis; I like riding in them and painting them, always striving to get better highlights so they look as shiny as they really are.

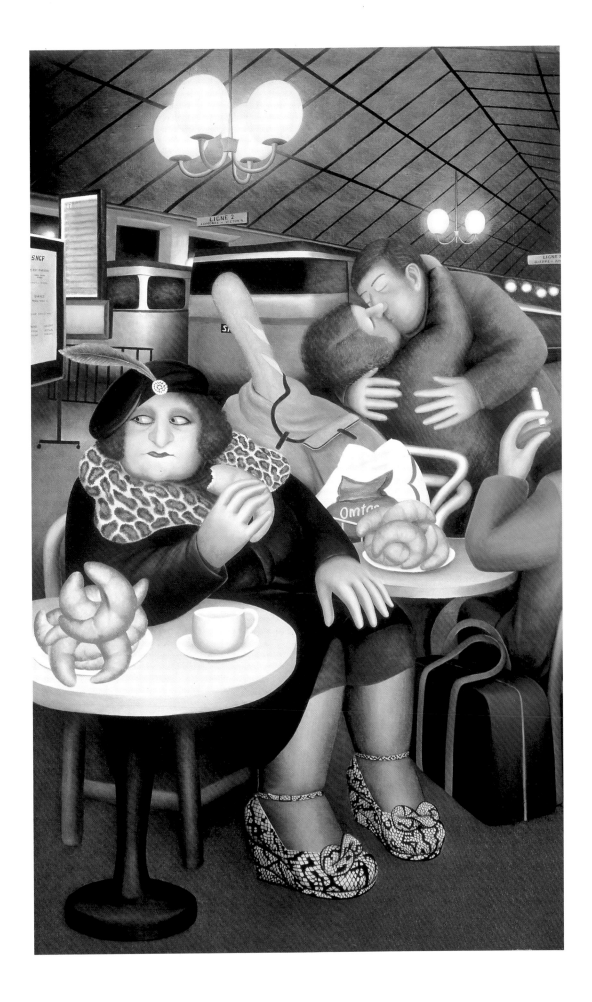

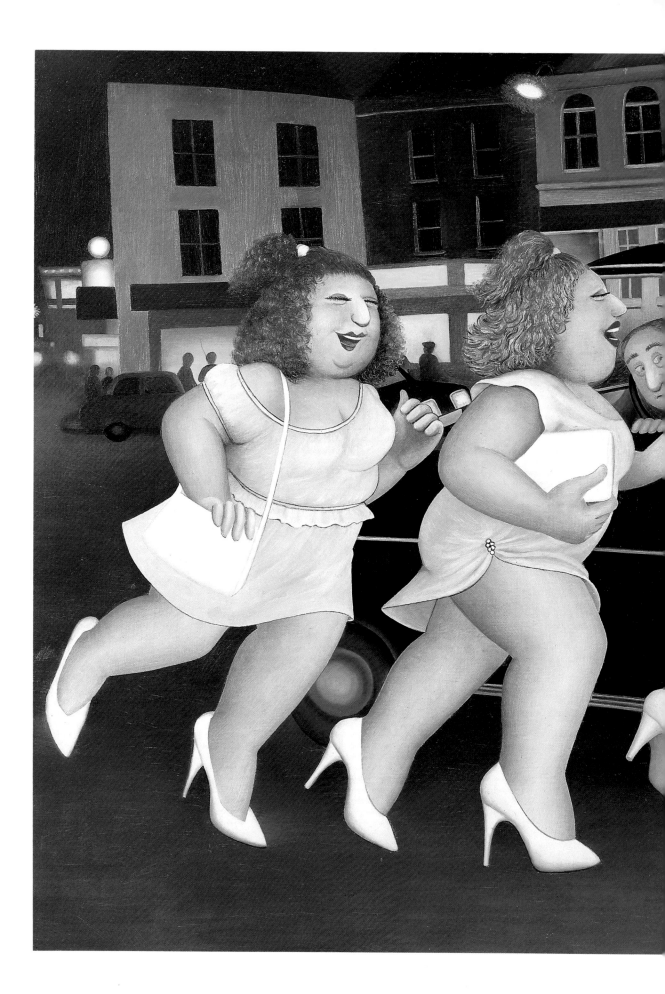

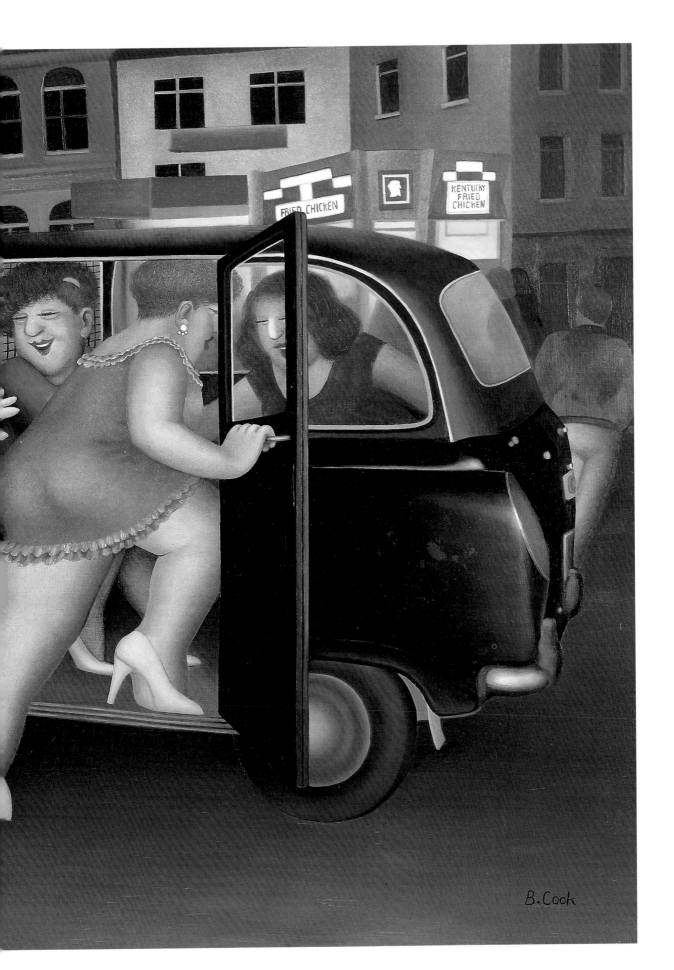

B.Cook

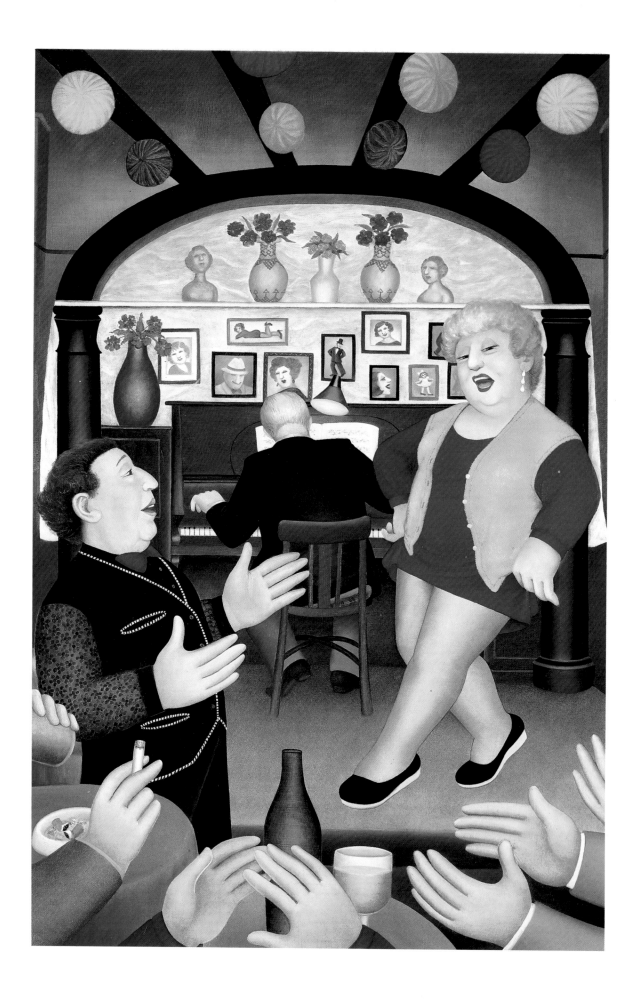

BODEGA BOHEMIA
(opposite)

We were led to this little music hall through some dark alleys just off the Ramblas in Barcelona. It gives employment to ex-music-hall stars who have had to retire but still enjoy performing. The man on the left is the Master of Ceremonies, encouraging the applause for the lady just finishing her song. This was in Spanish so I missed the saucy bits, thoroughly appreciated by the rest of the audience. All the restaurants, cafés, bars and clubs in Barcelona only come to life at about eleven o'clock at night. So it was bedtime at five for me after a day of sightseeing, and up again at twelve for a night of frivolity.

LA PALOMA DANCEHALL

We had to join a large queue outside the Paloma Dancehall in Barcelona waiting for the doors to open, so popular are the two daily sessions here. They are held in a lovely old hall with decorated ceiling, balconies and boxes, the dancers rushing for the seats round the floor and the onlookers climbing the stairs to the balcony. The Paso Doble was the favourite dance and very well performed it was too, with nicely rounded hips swaying seductively to the music. The man at the bottom left was greatly in demand as a partner and could take his pick amongst the ladies. All of these had beautifully arranged coiffures of every colour except white: no self-respecting middle-aged Barcelonese lady allows a grey hair to appear, I understand. I would have liked the picture to consist entirely of swaying hips but I soon found that I would need a few heads as well, and arms, which meant hands, too – something I always like painting.

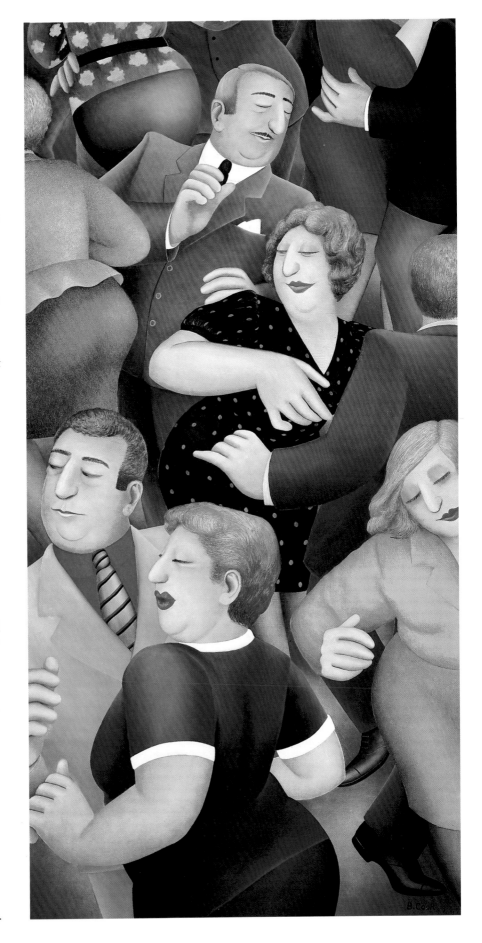

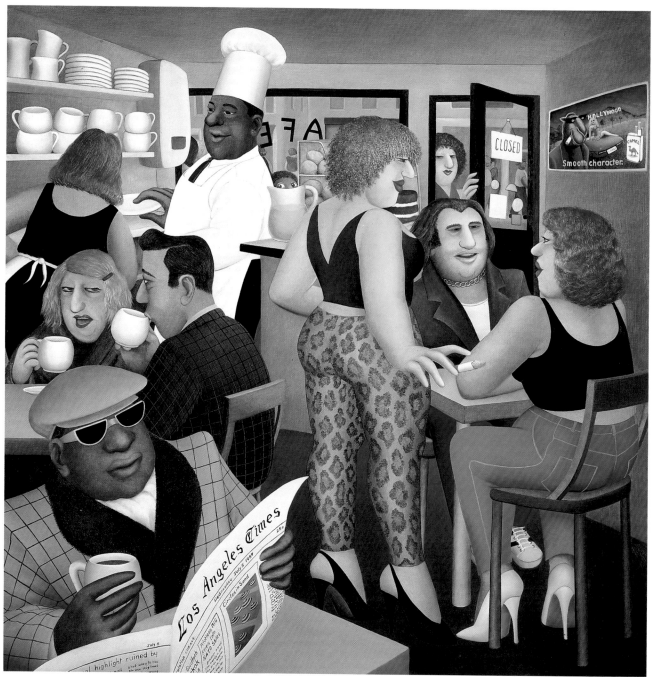

HOLLYWOOD CAFE

Here I am in Hollywood! Where you can't see me, at the back of the café and the only addition I've made to the scene is the advertisement for Camel cigarettes on the wall, which was a huge and very striking poster that I saw on hoardings all over Hollywood. After a visit to Forest Lawns (hoping to find Rudolph Valentino's grave), a bus took us back to Sunset Boulevard and we turned into this café. The chef was enormous and dressed in spotless white. I don't think his clientèle was glamorous enough to be ex-film stars: in fact the man sitting with two girls looked rather menacing and as we drank our coffee we speculated on what sort of business he was about. Monkey, I expect.

HOWARD JOHNSON CAFE (opposite)

This café was close to a hotel we were staying at in New York and visited often by us when we saw, indignantly, what it would cost to have a snack sent up by room service. I very much liked the design here, and the pattern the light fittings and columns made, so for once I have taken pains with the background. Breakfast was what we were usually after but I saw these ice-cream sundaes in full colour on the menus and I sampled one myself before leaving New York. It must be a terrible task for anyone trying to stay slim there: the portions of food are enormous and I rarely left a table without carrying a full doggy-bag away.

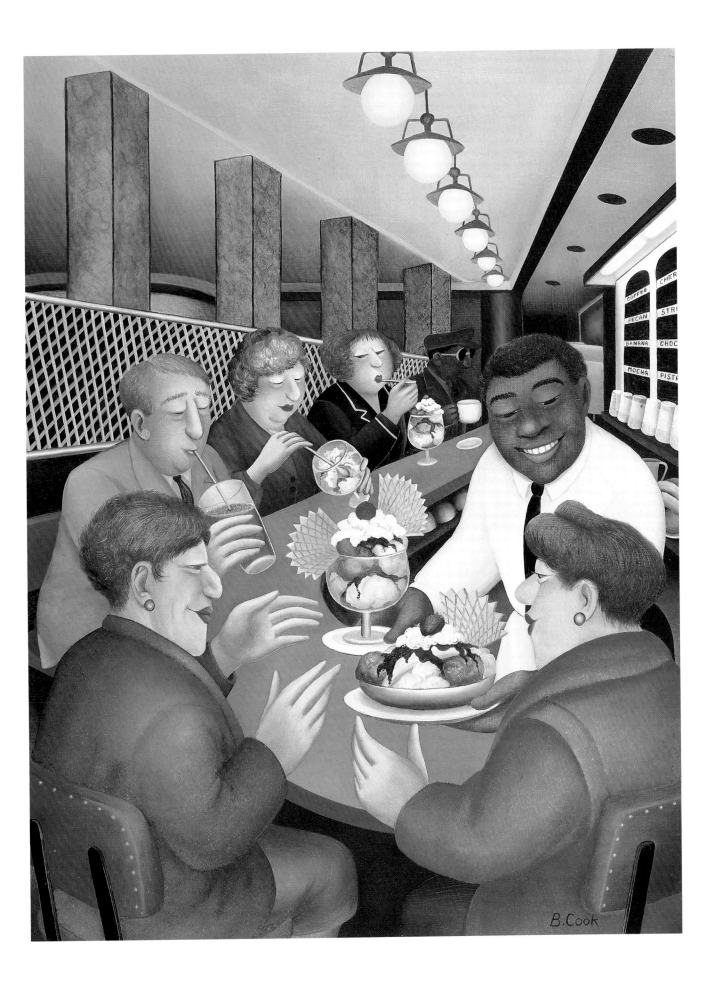

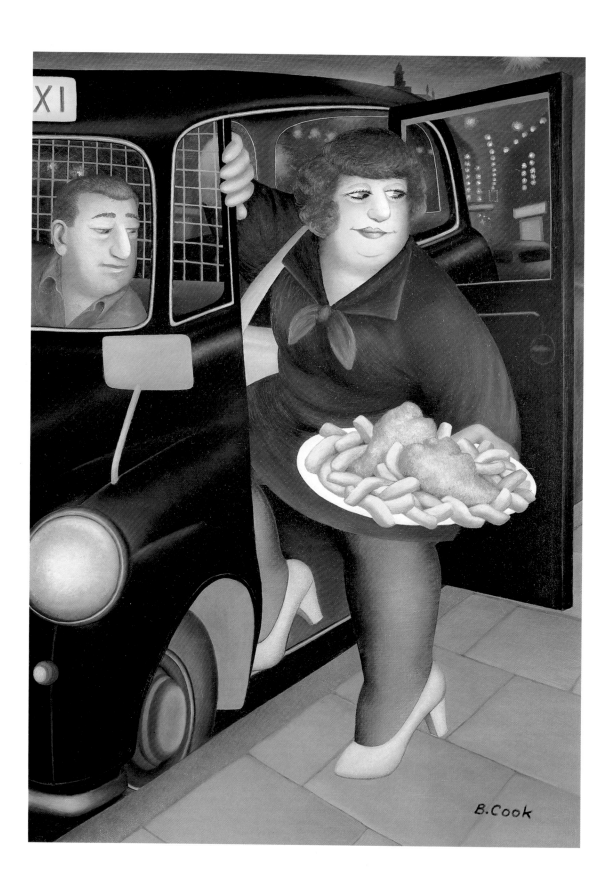

DINNER FOR ONE (opposite)

I think I must be hungry (or greedy), for I've painted several pictures of food recently. This particular episode I saw a year or so ago but have only now succeeded in painting it. This is exactly what I saw as I sat looking out of the window in a pub one evening. Taxis draw up continuously and offload groups of boys and girls at the entrance to the favoured hostelry, but this time when the door opened I was surprised to see a large plate of fish and chips emerge. It was followed by a tubby little lady who, after paying the taxi-driver, rushed it through the doorway where it was lost to sight in the crowds. I tried several times to compose this picture, finally getting the figure into the right pose and painting a plate of fish and chips while they were still fresh and glowing and not cold and greasy. So I heaved a sigh of relief when it was finished. My husband then pointed out that the taxi is missing one of its doors.

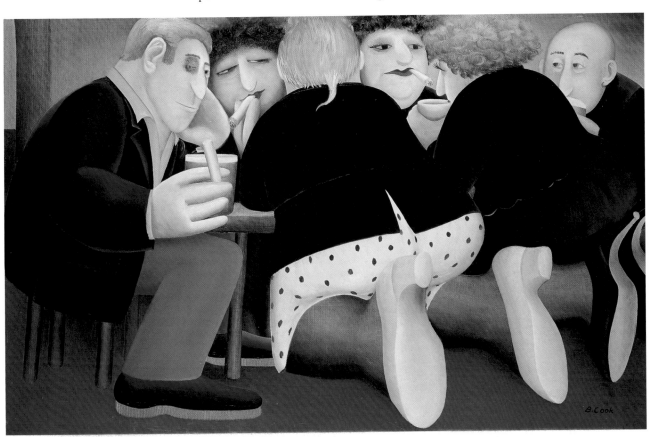

PUNKS IN A BAR

I am fond of this picture, painted in memory of a seedy little pub full of characters I no longer see, for – alas – it has been completely modernised. There were rather low tables, and, when these two girls arrived, no seats available, so they knelt down side by side to lean forward and join in the conversation. Once I saw a row of customers in here sitting silently with drinks, and every single one had either a bandage, bruises or a black eye. There are compensations, however, for as one old favourite pub disappears another takes its place, and just round the corner from here row upon row of sturdy trestle tables take the weight of lines of youngsters stamping and dancing to the jolly music of a German band. The evening in this pub starts off with decorum – and rapidly goes downhill!

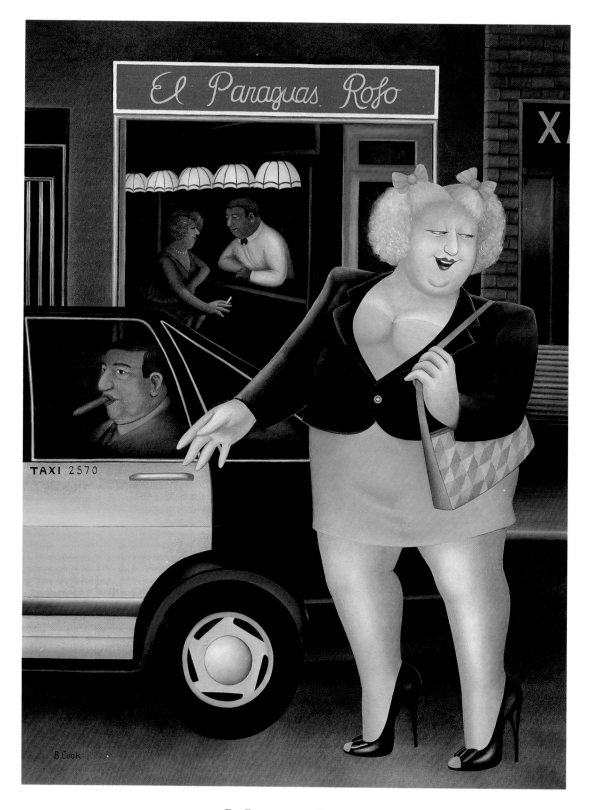

El Paraguas Rofo

Here is a rather famous prostitute. I first saw her on television in England, and then recognised her standing near our hotel in Barcelona, in front of a little bar we often used to pass at night. I say pass because it was so ill-lit that we were dubious about what we might find had we ventured inside. We have been to Barcelona twice and loved every moment there, for I am especially fond of cities beside the sea. This is a large painting (of a large girl) and each time I do one of this size I vow it will be the last: there are so many loud oaths and curses as I heave them on and off the easel.

Getting Ready

I was very taken by the dress with points that this girl was
wearing in the Ladies' Room on one of my visits there. The
three of them were leaning forward to add the final touches to
their make-up, and getting ready for whatever amusement the
evening would bring. No graffiti here, for this pub has been
completely modernised and redecorated, but in earlier days I
had plenty to read on the walls. One message writ large was
that 'Shirley gives Green-Shield stamps', which I was intrigued
to learn, and there were many useful telephone numbers and
invitations. A last flick of the comb through the curls and the
girls departed through the door, the many-pointed skirt
showing off to full advantage when its owner did a little
dance on the disco floor.

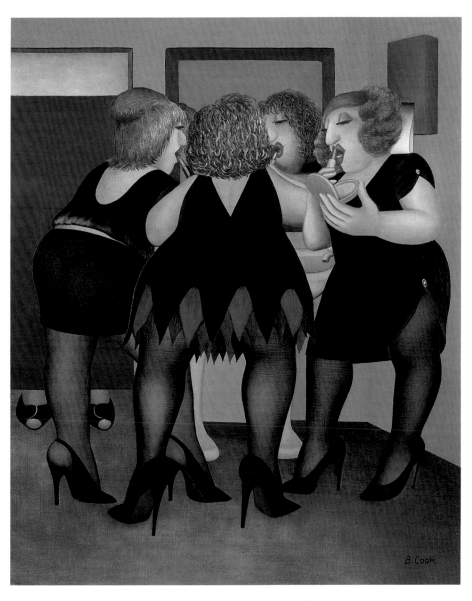

THE FUN FUR

In this little pub there were two rooms, one very dark except for the light at the bar and entered by going up a few stairs. On one of our visits I saw this small stout lady standing on her own, wearing a big fun fur. I always carry small white cards and pencils with me when I'm out, and do any drawings I need in the concealment of my handbag. Sometimes it is years before I use them and, although I've more or less lost my memory for most things now, I can remember immediately any drawing I need and where to find it amongst the pile of cards stacked on a shelf. I had often seen the view of the further bar and wondered whether I could reproduce it, and this lady made up my mind to do something about it.

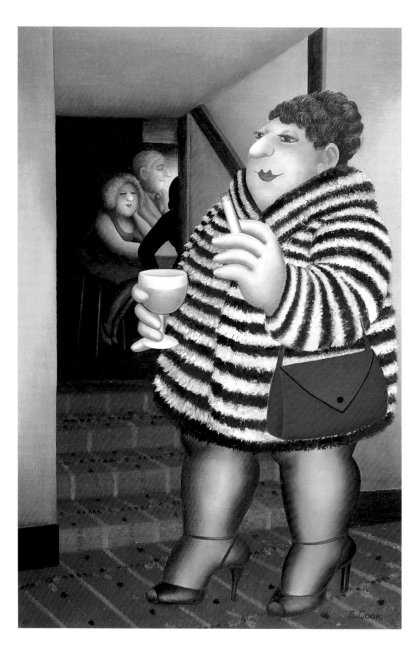

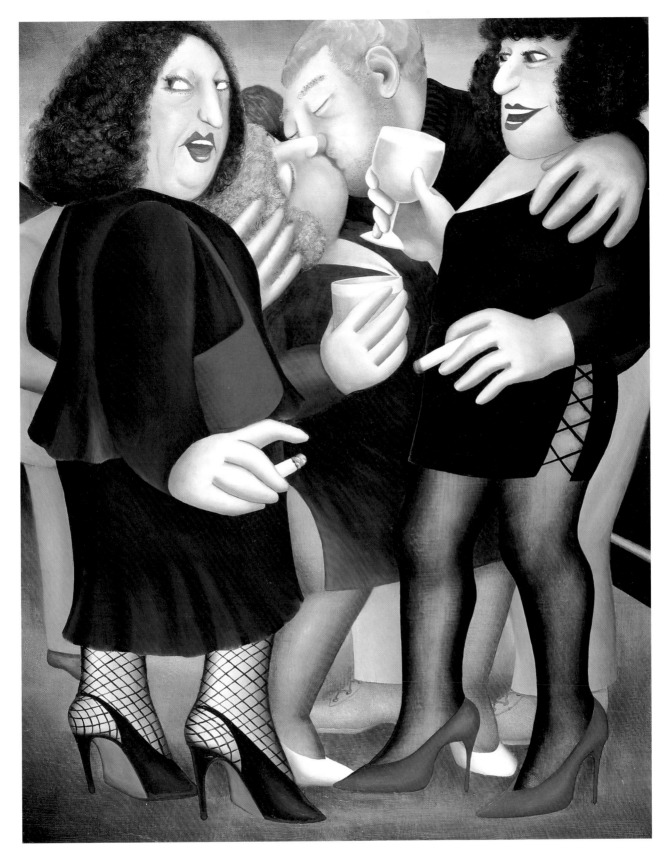

KISSING TIME

This episode stayed in my mind because of the roughness of the man kissing the girl in the middle. The group were quietly drinking at the bar when he ambled up to join the conversation, and soon after he took the girl in his arms for a passionate kiss. I did not envy her but no punch-ups followed so he must have been a friend – of sorts.

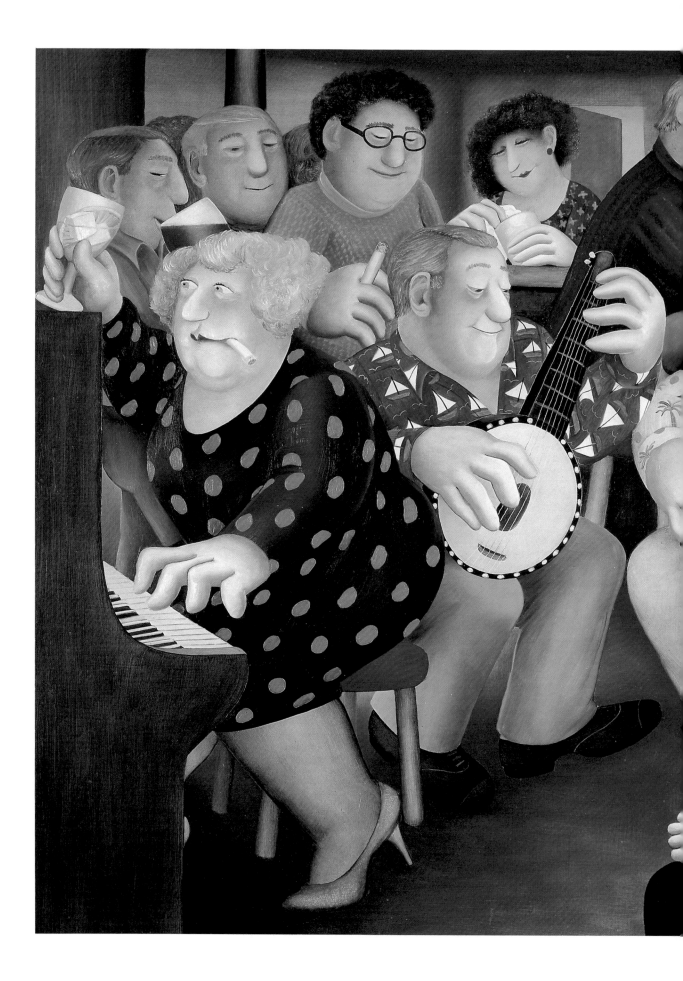

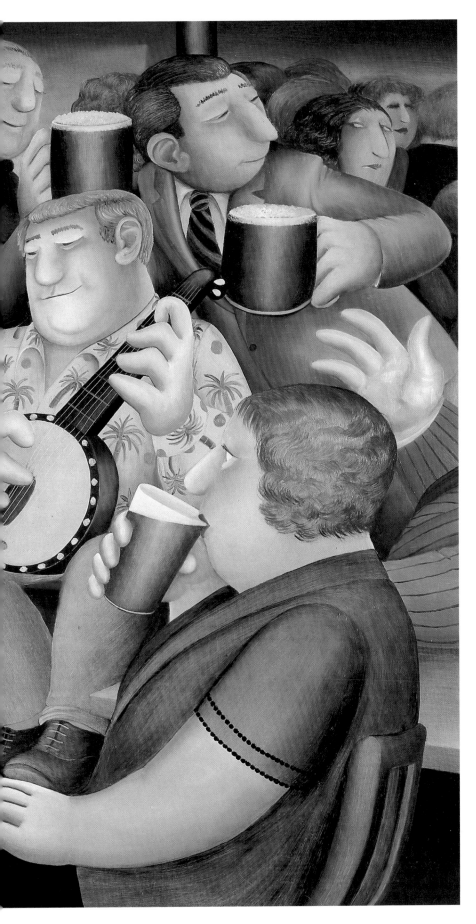

THE BANJO PLAYERS

A banjo concert used to be given
every year in the Dolphin when
these two players came here on
holiday and joined Betty, the
landlady, at the piano. I have always
liked the banjo, not often heard
now, so on their arrival at the pub I
energetically elbowed my way to
the front of the crowd, determined
not to miss a treat like this. They
were so good, feet tapping while
fingers flew, and it seemed that the
session was over all too soon. One
player has since died so there are no
more concerts – I was fortunate to
have been at this performance and
glad I was able to paint the picture.

Magical Evening at Glyndebourne

This celebrates an evening at Glyndebourne, sitting in a box and watching *The Magic Flute*. There were certain difficulties to overcome here, one of them architecture. It took a long time to combine an audience, orchestra and performers without having a back view of heads as the centrepiece. In the end I rearranged the seating to enable me at least to show the profiles of the two main figures, absorbed in the wonderful performance. This is the second opera picture I've painted, the first one being from a visit to Covent Garden to see *Madam Butterfly*; when I finished it I saw immediately that the members of the orchestra looked exactly like garden gnomes, and it has remained hidden from view ever since.

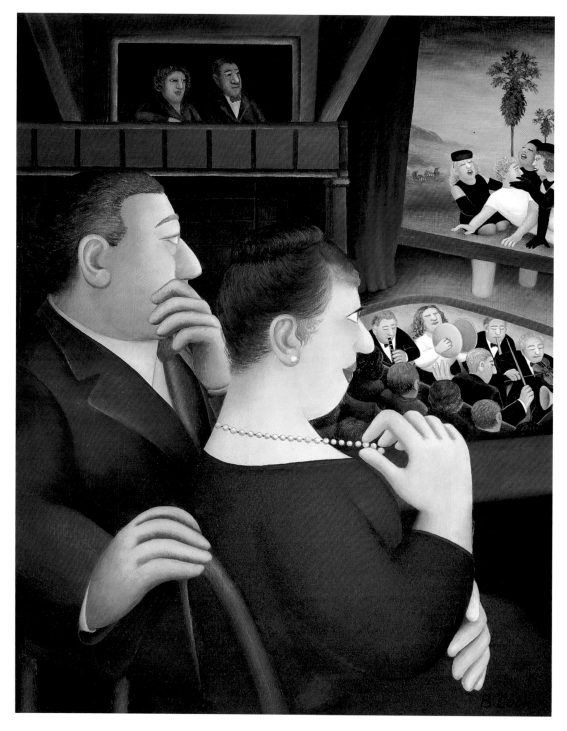

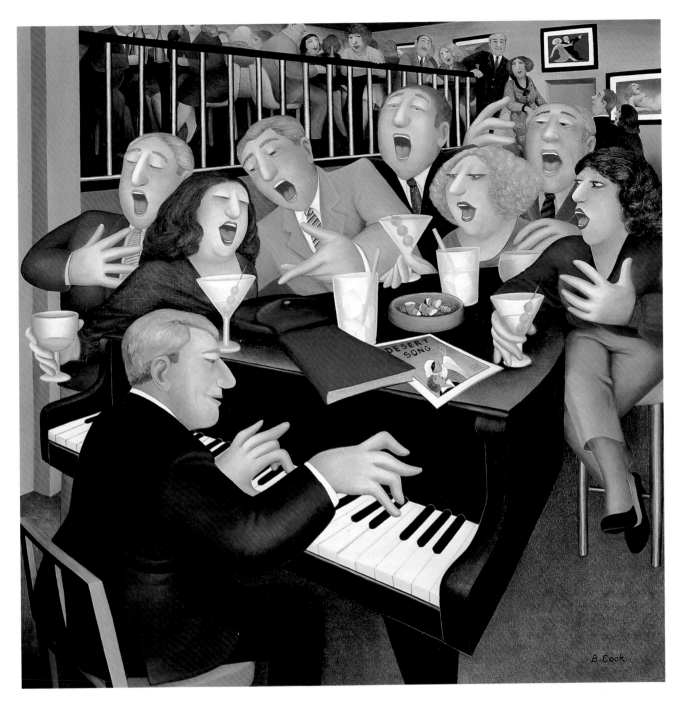

BIG OLIVES OR LITTLE OLIVES

This sing-song took place in a very nice restaurant in Philadelphia where, after wining and dining, a group of friends gathered round the piano to perform songs from the shows. What a lovely evening: everyone enjoyed the unexpected entertainment and I found the enthusiasm of the singers very exciting. The picture I hoped to get was already forming in my mind as I drew the people and took some photographs. Back home with pencil poised, I quickly learned that it would need a very careful arrangement indeed for me to be able to show both the singers' faces and the pianist's, as well as his hands at the keys. A further difficulty I had was in painting the cocktails – Vodka Martinis made with the utmost care for our friend Norman, who likes a cold glass, lots of vodka and a little olive. Norman always enquired about the size of the olive when ordering his drink and this led to the name of the picture.

LADY WRESTLERS

The first wrestling match I saw frightened me so much I left
half way through. Now I know the cries of pain do not
necessarily indicate imminent death, I shout and cheer with
the rest.

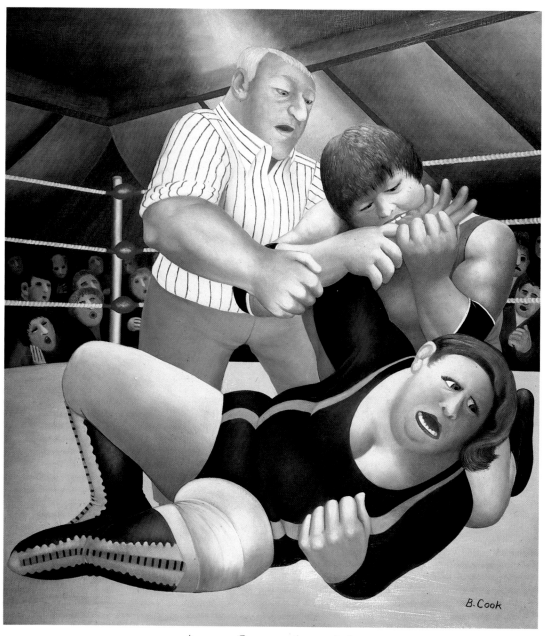

AT THE CINEMA *(opposite)*

When I was asked to do a poster for the British Film Institute I felt the best thing to paint would be some people engrossed in a jolly good film, and here my problems started. Some time elapsed before I could think of a scene sufficiently compelling to keep an audience spellbound. Then I remembered a story told to me years ago by a friend, a terrifying episode concerning a demand for a set of lists to be typed immediately, or severe punishment would result. The story certainly kept *me* spellbound, and with some minor adjustments it fitted the screen perfectly. Now they are all riveted to the plight of the poor woman who must frenziedly tap the typewriter keys if she is to escape retribution. I drew the interior while watching a film in one of the local cinemas, not an easy task in the dark and I was relieved to find that the drawings made sense when we came out into the daylight.

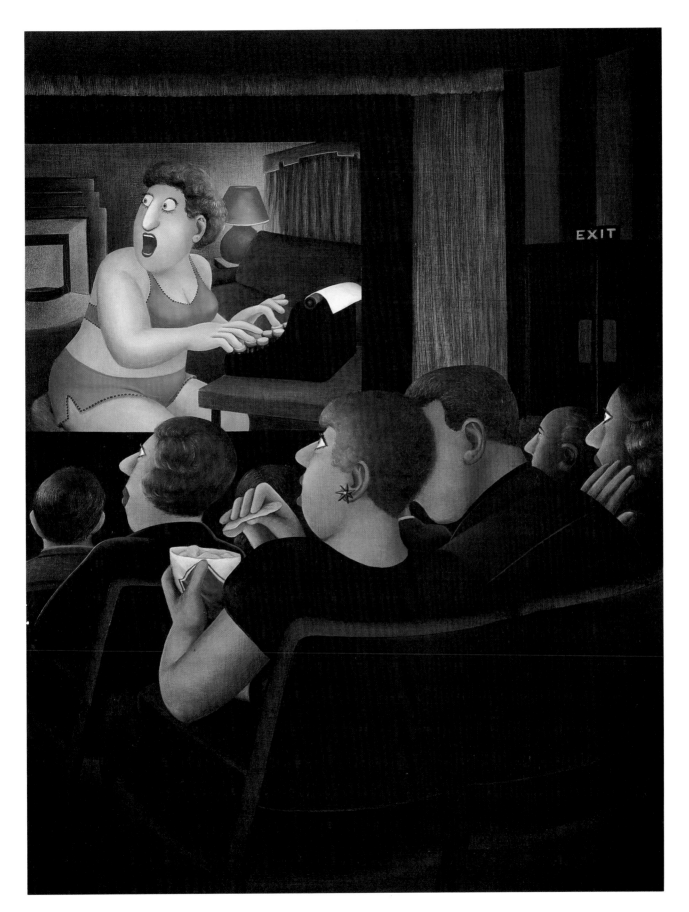

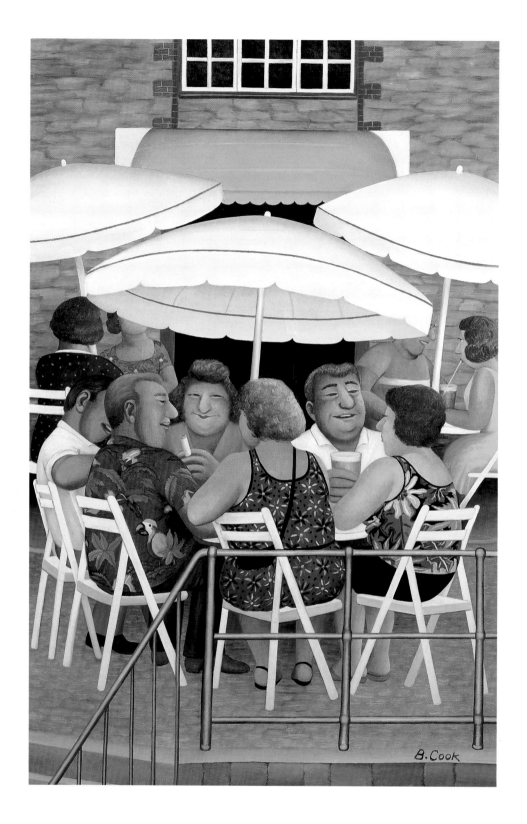

SUMMER AFTERNOON

These tables set out on the quay beside the water were very well patronised last year in the hot summer sunshine. The children could look at the fishing boats and play around while the parents rested swollen ankles and drank in the shade of the umbrellas. One big family group had gathered round a table and were deep in conversation, with much laughter and occasional sorties through the door at the back to replenish the drinks. I thought this would be an ideal scene for a picture to remind me that we do sometimes have very hot summers, and it was a chance for me to paint a favourite shirt of mine, covered in parrots and palm trees.

MOTORWAY CAFE

I like motorway cafés, especially since the food has improved so
enormously. Have you tried the fried bread recently? I can recom-
mend it. It must have been mid-morning that we called at this one,
when businessmen and travellers pause for coffee and a look at
the papers. The decorations have since been changed in here, and the
large basketwork lampshades (the original reason for the painting)
have sadly disappeared.

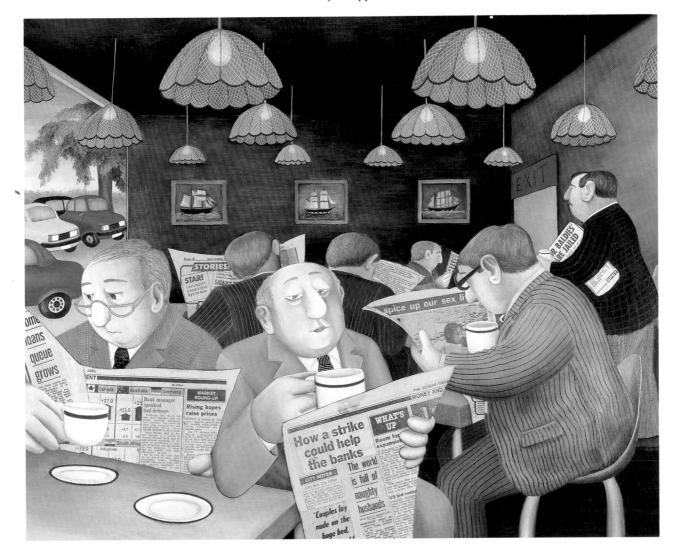

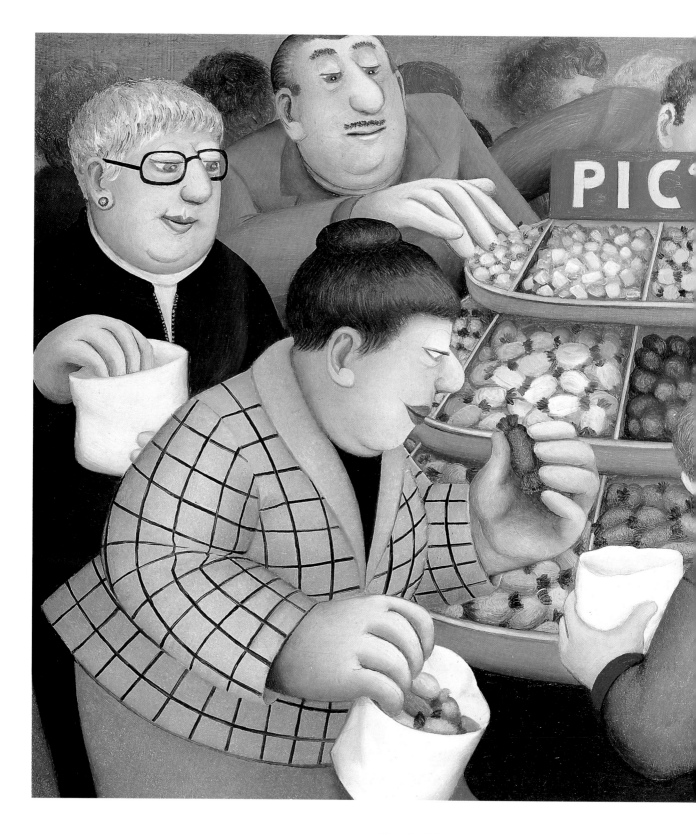

Pic 'n Mix

Pic 'n Mix is one of my favourite occupations, always
followed by sit 'n munch as I'm painting or drawing.
There are always plenty of others with busy fingers
ready to rustle through the goodies with me at this
counter. I don't feel guilty about the large floppy

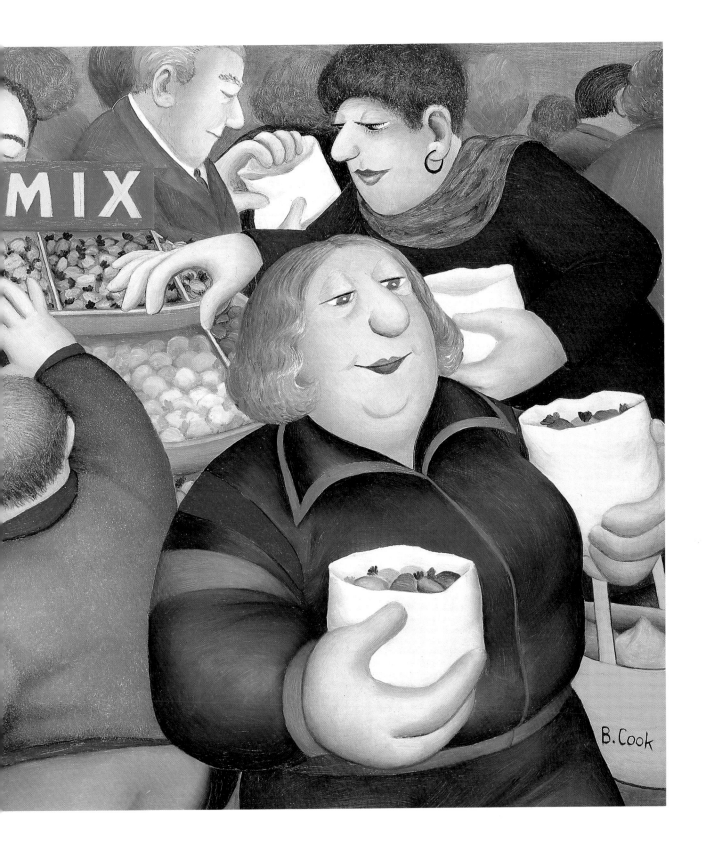

waistline this activity has produced – old age allows
these little indulgences, I tell myself. I used to feel very
guilty indeed, though, as I crept in to steal my
granddaughter's sweets while she was asleep in bed. I am
the only grandmother I know who would stoop as low as
that. Now she is slender and graceful and I am pear-
shaped, so perhaps I've got my just desserts. I didn't
have too much trouble preparing the materials for this
picture – an extra large pic 'n mix was purchased
specially for it.

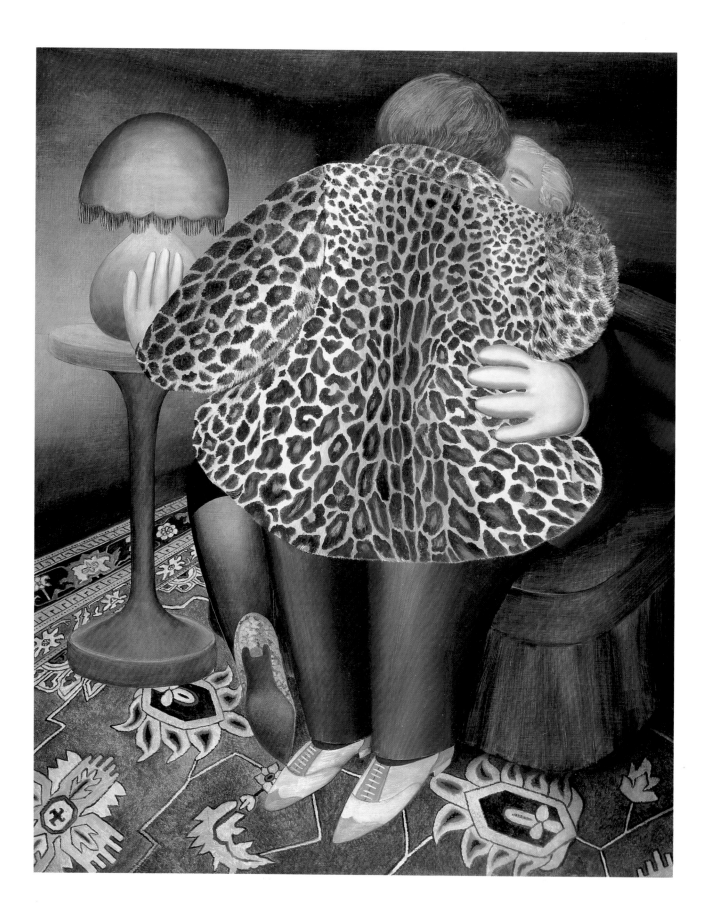

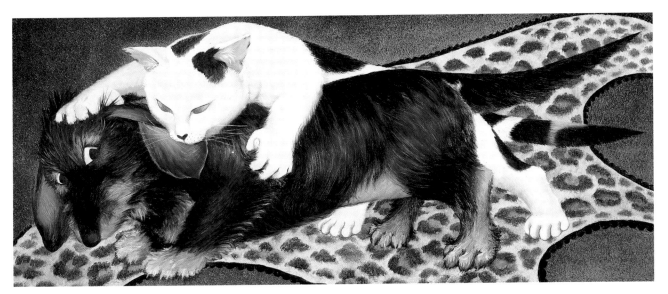

THE LEOPARDSKIN COAT *(opposite)*

The fur coat here came from a magazine but the lizard shoes I found in a charity shop. The previous owner of them had feet half the size of mine so I just bring them out now and again to use in paintings. I would like to be the owner of the two-tone shoes the man is wearing but I have never been lucky enough to find a pair. There is a bold attempt at a carpet in this picture, copied from the one that lay on the floor of my painting room until it finally disintegrated under layers of oil-paint, turpentine, cigarette ash and dog-bone remains.

FELIX AND LOTTIE

The sofa in the painting room also suffers from animal activities, in this instance Lottie (the dachshund) and her friend Felix, the cat with the large paws. There is a mock-leopard rug draped over the sofa, and I was very taken with the effect of their fur against the spots. And it isn't only fur that looks well on this rug . . .

NUDE ON A LEOPARDSKIN

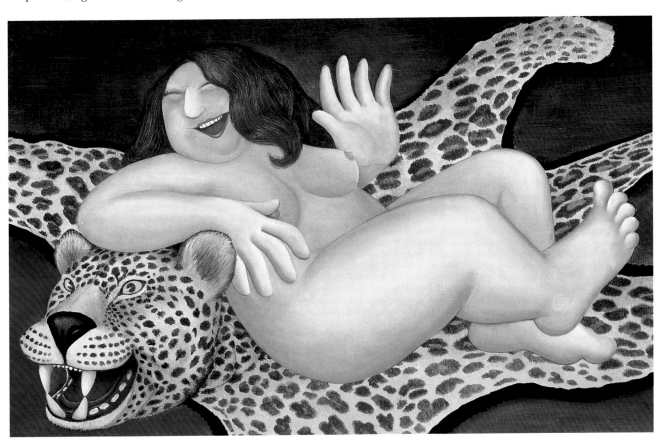

PERCY AT THE FRIDGE

This picture, which belongs to my husband, shows his much-loved cat
Percy and some of the food he deemed suitable for one of such
aristocratic pedigree. I needed a kitchen background, so various parts
of our own had to be used as a model, and the champagne bottles I
copied from illustrations in magazines. In fact I keep pictures from
magazines and newspapers of all sorts of things I think I may need for
a painting. I'm sorry to say poor Percy is no longer with us in the
flesh – only in spirit and on the sitting-room wall.

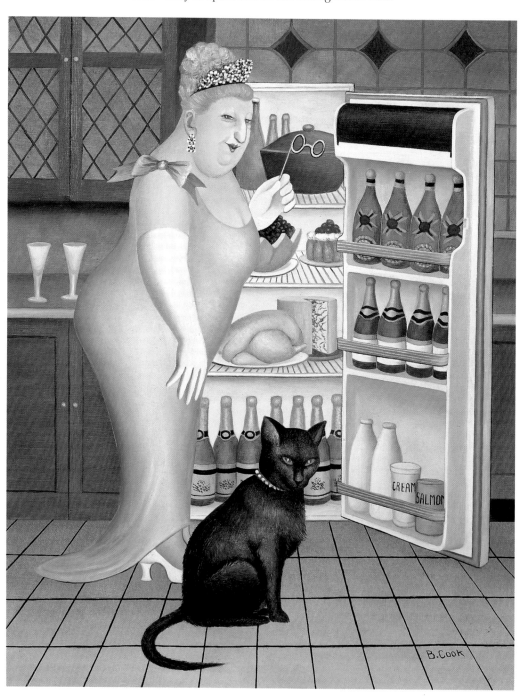

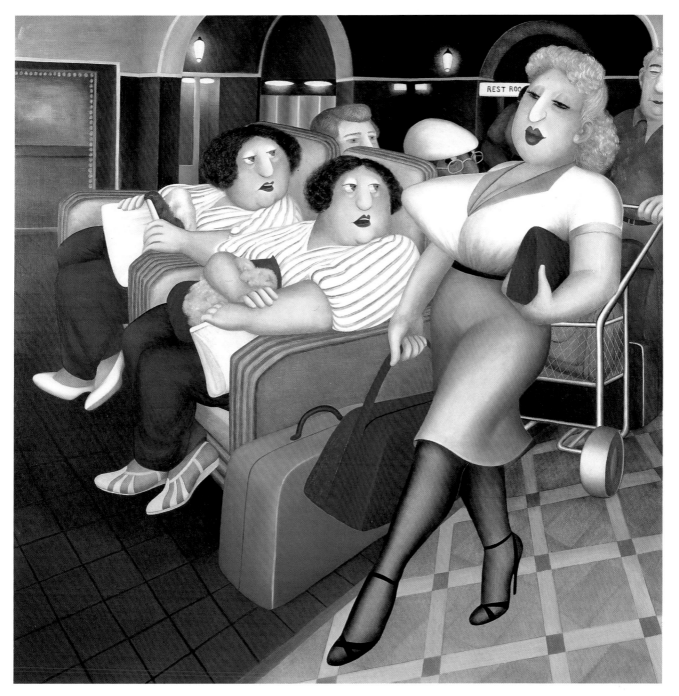

TWINS

Pictured here is a combination of people and places I have seen on various trips across America. The background is Los Angeles' Art Deco railway station, much admired by me when we had a stopover there between trains. Twins fascinate me and I had seen these two watching an outdoor performance on a pier in San Francisco. They fitted nicely in the pair of seats. I had drawn the lady with the outstanding figure on our first visit to the States, when a long wait at Miami Airport was enlivened considerably by her arrival. Believe me, I have not been able to do her justice, and a ripple of excitement went through the waiting room as she entered. I've painted her as I last saw her, proudly striding towards her boy-friend, waiting to meet her in New Orleans.

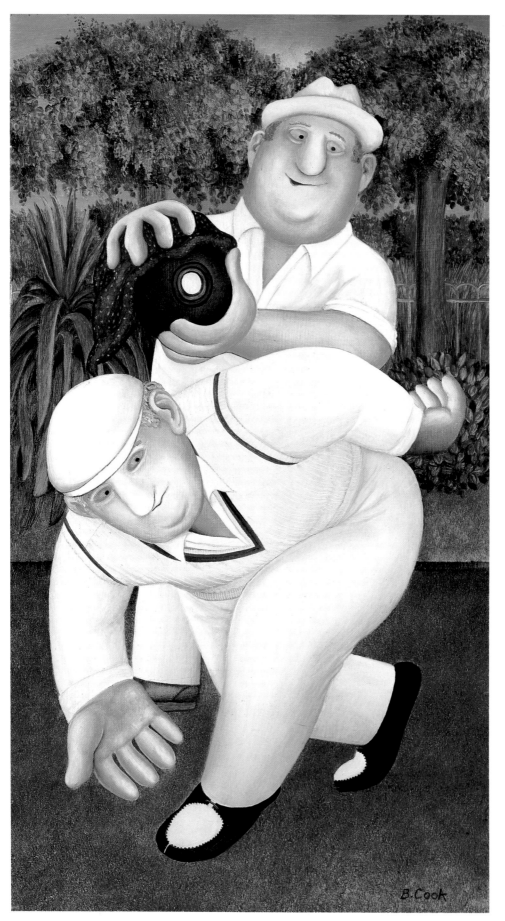

PRETTY WOOD

Some of my paintings appear because of a phrase I like the sound of, and I still have a few hovering on the sidelines of my mind ready for a painting to be attached. 'Pretty Wood' caused this one, a term of admiration for a good ball bowled, they tell me. I'm not sure if it is possible for anyone to stand in this position but he has just rolled his bowl along the green, and the composition fitted the board I was using. The men in the teams I see are so good-looking that I once tried to persuade my husband to join so I could mingle with them. I learned last year that this painting had been stolen from its home in Canada – by a middle-aged lady, perhaps.

LADIES' MATCH
(opposite)

What a grand swipe at the ball this girl is about to take – if that is the right expression. It was the girl's leap in the air that started this painting off, but getting her partner placed to smash the ball back again (and still remain in the picture) was not so easy. She needn't worry about being in the right place, though, for although this is my third tennis picture none of the players so far has ever been limited by markings on the court. I always like the tennis season to start – it means summer is here, and as just watching a game leaves me as exhausted as the players themselves I can go home satisfied with all the healthy exercise I feel I've had.

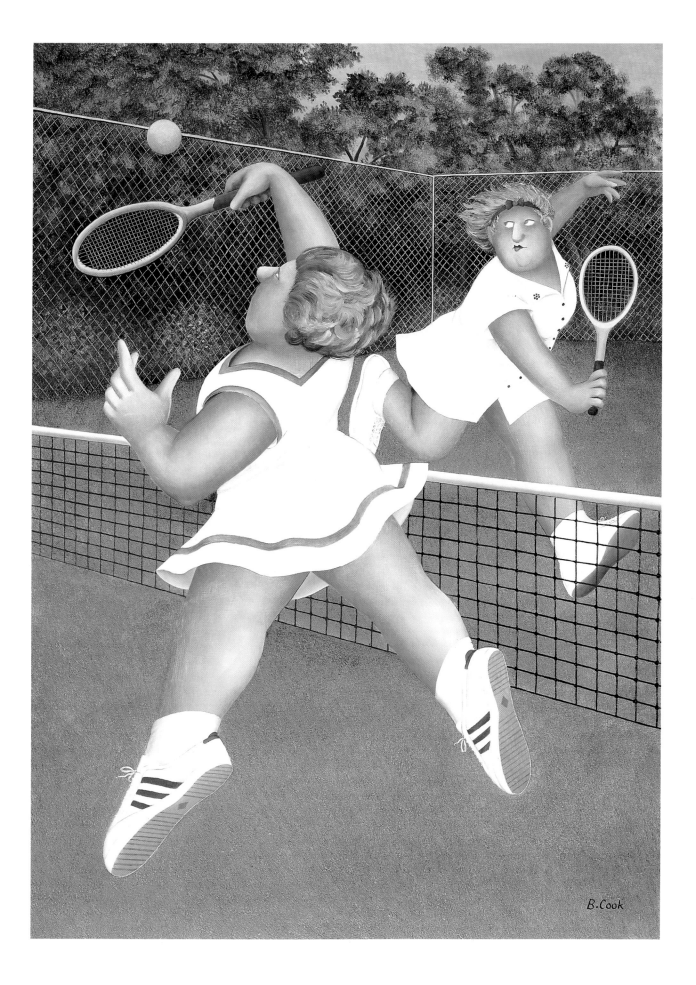

B.Cook

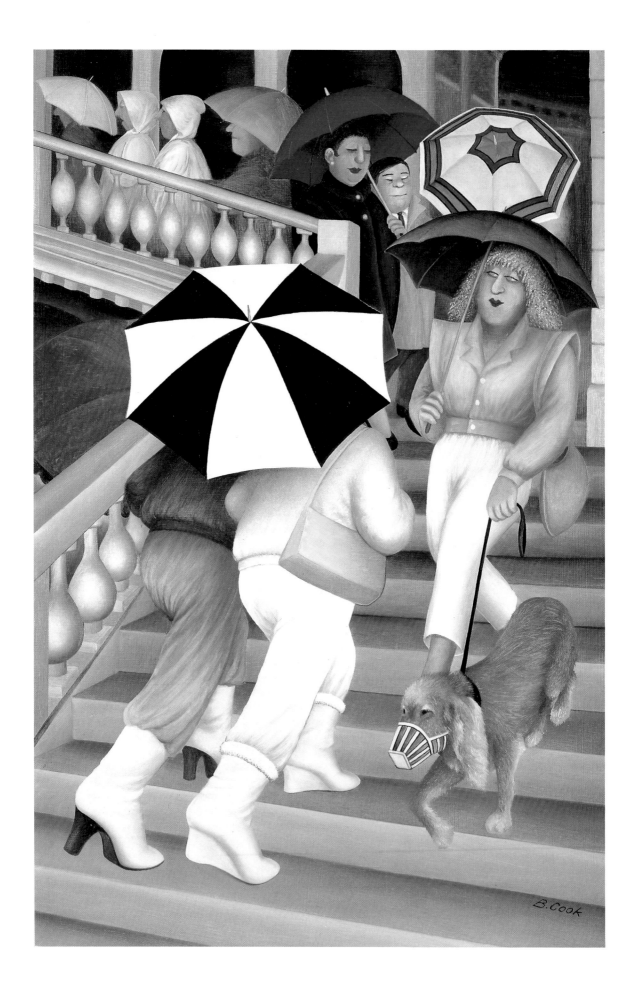

THE RIALTO BRIDGE *(opposite)*

This scene is one I watched as we sat drinking coffee while waiting for the rain to stop on a sightseeing holiday in Venice. We are good tourists and like walking, so we followed the instructions in our very good guidebook and learned many, many things about the buildings and artists. Each new revelation, and gasp of amazement, would be followed by welcome refreshment in a nearby café, and in one of these I had the most gorgeous ice-cream I've ever tasted. Dogs are very popular in Venice, most of them wearing plastic muzzles as a safeguard against rabies. This was approved of by me, being highly nervous of all the health hazards I imagine to be awaiting my arrival on foreign shores.

WALKIES

Here are two ladies I used to see on the Hoe, and one cold day I found them chatting together, with the portly little dog patiently waiting for the conversation to finish. All three were dressed for winter and looking very cosy in thick warm coats. I had often wondered how I could use in a painting the decorative white colonnade on one of the paths leading to the sea-front, and this proved to be my opportunity. As I drew the picture the ladies gradually got bigger and the colonnade smaller, eventually receding to just a suggestion in the background. This is something that nearly always happens unless I am very strict with myself indeed.

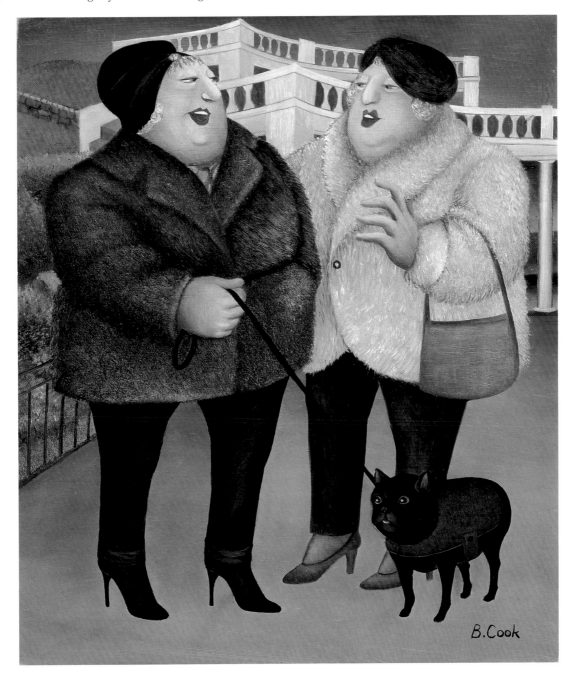

B. Cook

BASIL WARTHOG

Isn't he handsome! Warthogs were great favourites of mine when we lived in Africa, but they are very shy and I mostly only saw their backsides running off into the bush as the car passed by. There was one, though, named Basil, who was kept in an enclosure; we used to visit him sometimes, and always found him happily wallowing in mud. When the Portal Gallery wanted a pig picture for one of their shows I decided he would be the one. Here he is quietly sitting in front of a splendid display of sweetcorn plants, the one and only time we managed to grow them here.

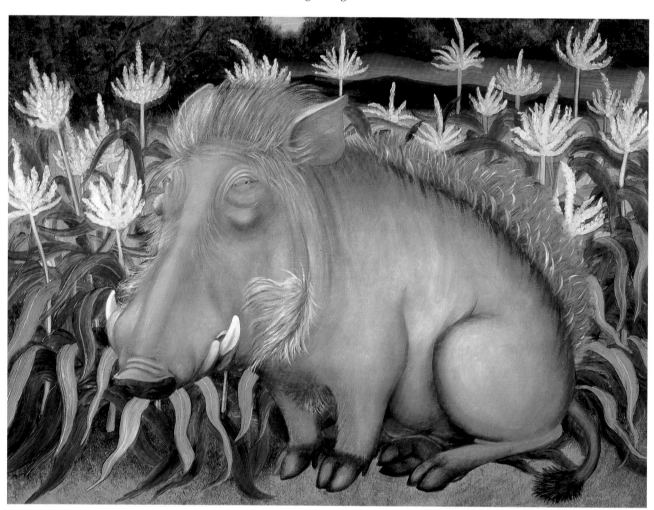

LADY OF MARSEILLES *(opposite)*

I painted this picture after a visit to Marseilles some years ago. It is an exciting place, dangerous too, and we were warned about which streets never to enter. I don't need warning twice, so we left these streets well alone and sat safely on the quayside in the evenings, content to watch activities on the magnificent yachts and the bustle around the small pavement cafés. This girl, dressed in a minute leopardskin outfit and sporting a golden tan, busied herself going here and there, pausing for a chat or drink, and occasionally disappearing into a dark alley. Her final appearance was from a nearby doorway with three small dogs eager for exercise, crossing the road in front of us as we walked back to the hotel; she left me with this last view of her.

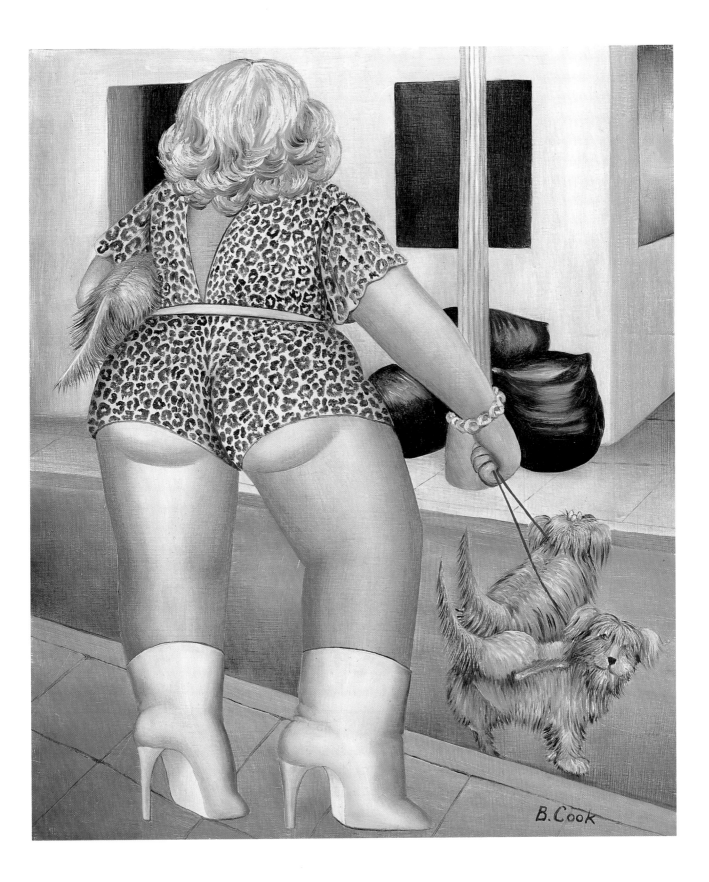

B. Cook

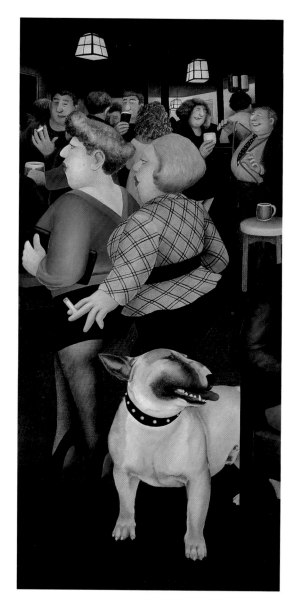

Dog in the Dolphin

Dogs of all sorts come in here and I'm always
pleased to see them. They aren't allowed in many
pubs, for reasons of hygiene, I think. I'd rather
have more dog and less hygiene as in France,
where they are fed titbits from the restaurant
tables and happily lounge about on chairs in bars.
The one in this picture arrived beside our table
and stood gazing into space for some time: he
was so good-looking that I took his photograph.
 When I began to arrange the picture I
remembered these two girls passing by, wobbling
a little on very high heels, and so here they are to
make a rather nice background.

SUSIE

Susie was a dear little dog that lived near the Hoe and I saw her nearly
every day when we were out walking. She grew stout with the
passing years and although still ready to run up and down the street
to bark indignantly at cars, much of her time was spent slumped in
the sun in the doorway of her owner's house. I liked her hairstyle so
much that I photographed her one morning, and when the Portal
asked for a picture for a Christmas show I decided to use this. She is
in front of a bench, in the park she often ran through to meet her
master in the evenings.

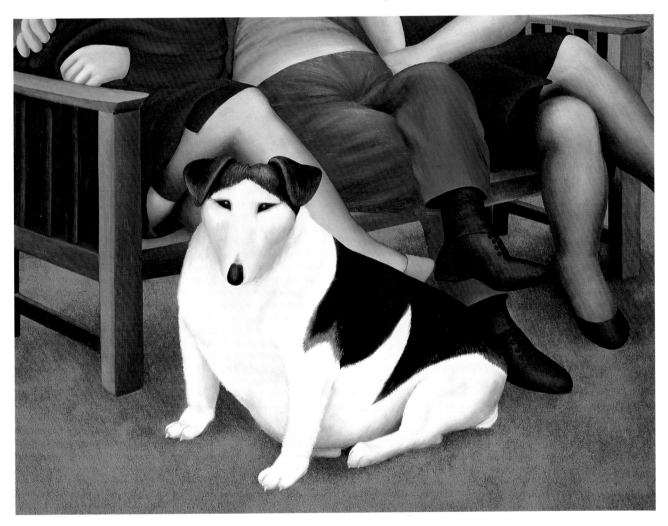

THREE FOR A QUANGO

A Christmas show arranged by the Portal Gallery was based on the theme of proverbs. Having discarded all those likely to give me problems, I chose the easiest – 'It Takes Two to Tango'. But I had been doing rather a lot of dancing pictures and was trying to wean myself off them, so to make it a little different I decided I would just use men. I started off with the two on the right, and then found another I'd drawn so I added him too. Then I had to alter the proverb to fit them, so it became 'It Takes Two to Tango, and Three for a Quango'. Fortunately I managed to stop there. The background is made from strips torn from a high-class ladies' magazine, carefully pasted and placed – a very satisfying way to while away a few hours.

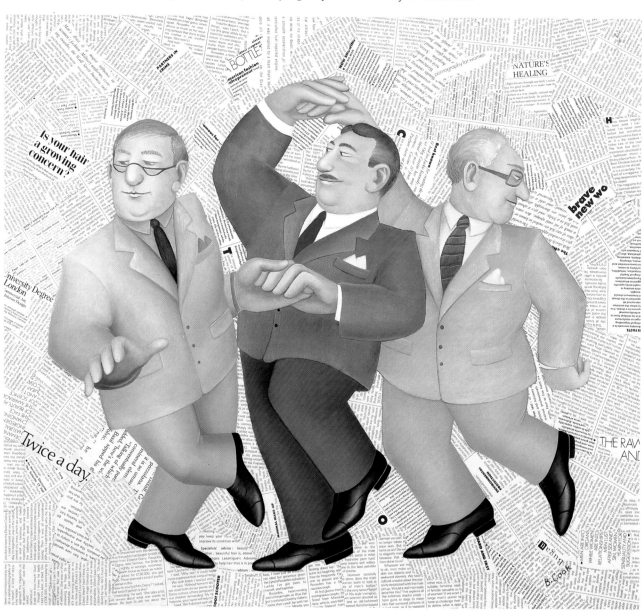

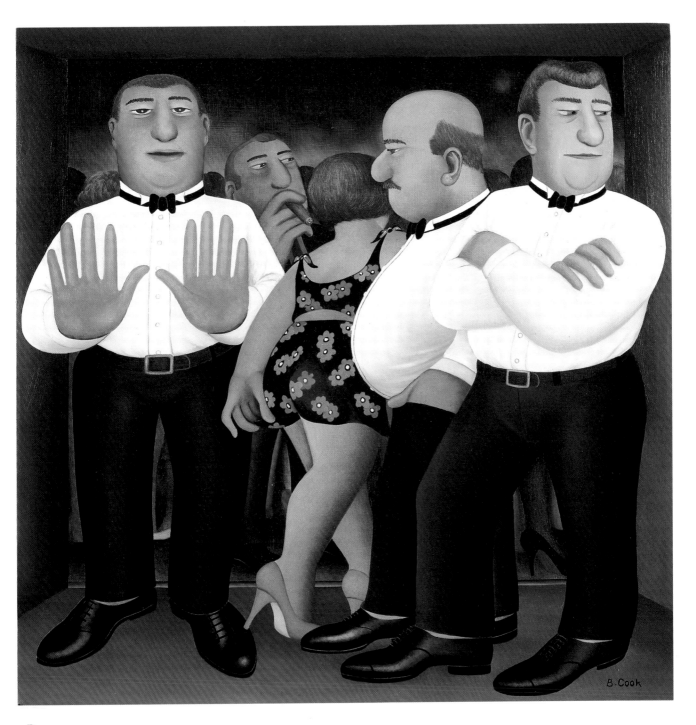

BOUNCERS

Many's the time I've sipped half-pints of beer and watched the bouncers getting ready. They are usually just assembling for action when we arrive, talking and adjusting their bow ties. I'm reassured to find them there; sometimes I ask if they'll let me in (am I old enough?). They always do: I don't think I look like trouble. The girl in the natty outfit is adjusting her shorts, something I find they have to do quite often, and especially the little tiny stretch skirts. We sit near the doorway, so as to get a good view of the girls arriving and to see what the latest fashions are. At the moment their hair (big, frizzy haystacks) is giving me some problems and I hope the style changes soon to something easier for me to paint. The great drawback is the volume of sound from the videos, so loud that even the seats throb in time to the music. The level rises as the evening wears on and then we know it is time for elderly grandparents to leave.

BOUNCERS BACK

The bouncers from behind – the view I have when they gather in the doorway ready for business. They have to be very strict about the age of the people they let in but this girl is all right. She is going forward to join a merry group visiting pubs before going on duty themselves as bar-staff, all dressed in identical outfits. I remember them well because as they sang and danced together one of them punctuated the music with shrill blasts on a whistle she carried, and I wasn't sorry when the time came for them to depart for work.

BREAKFAST TIME (*opposite*)

They serve wonderful breakfasts in Littlewoods in Plymouth. I haven't yet indulged myself, but I'm terribly tempted each time I go in there, which is often. There is a choice of five items for only 99p and it's such a bargain that an orderly queue soon forms when the restaurant opens. As you can see, I've had many a good look at the food passing by, and admired the excellent way it is cooked. The weather was cold when I painted this, just right for a piping hot breakfast, so one of the customers is warmly dressed in a big spotted mock fur.

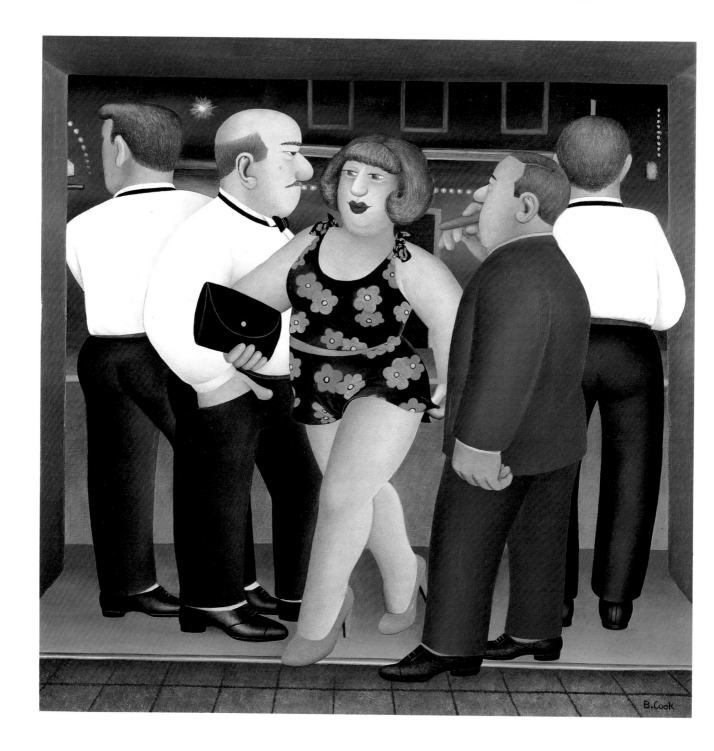

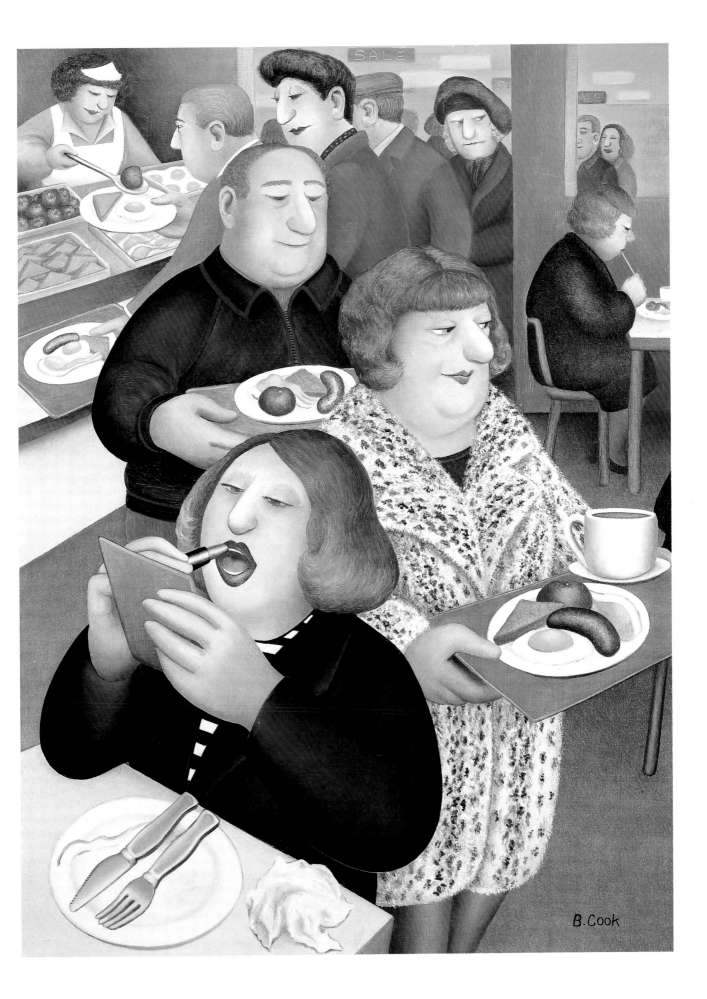

B.Cook

PACKING THE CAR

Some friends of ours came to stay and this is a picture of them packing the car ready for departure. As you can see, there is rather a lot of luggage, even a big pile of books ready to fall off the front seat. This is one of my few attempts to paint the street where we live, much busier in real life and with many more cars, but three were the most I could manage to fit in. Although I don't drive I rather like cars, especially those expressing the flamboyant tastes of their owners. One parked near here had a complete beach scene in the back window: the sand was a yellow fur fabric on which small furry animals reclined in bathing suits, a few shells and a miniature bucket and spade adding the final touch. My husband has yet to be convinced that he too needs something like this in the back of his car.

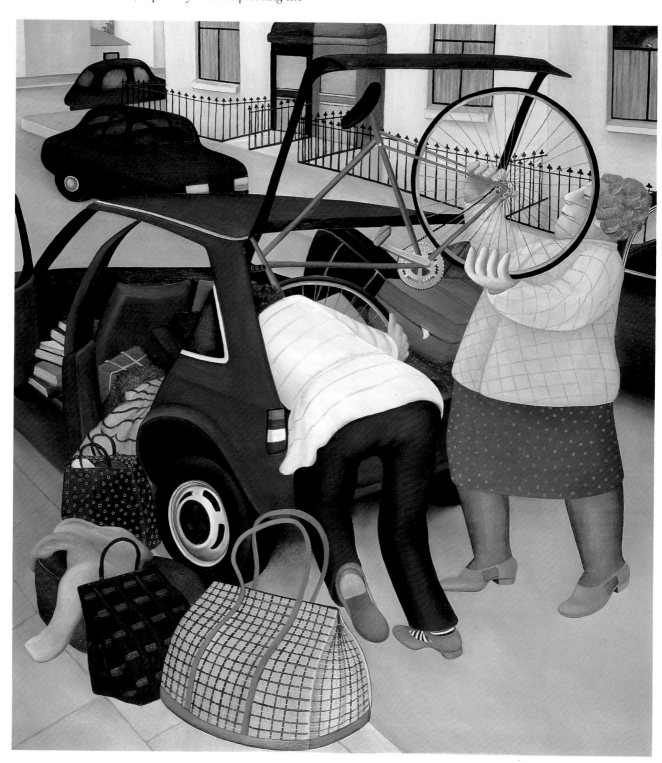

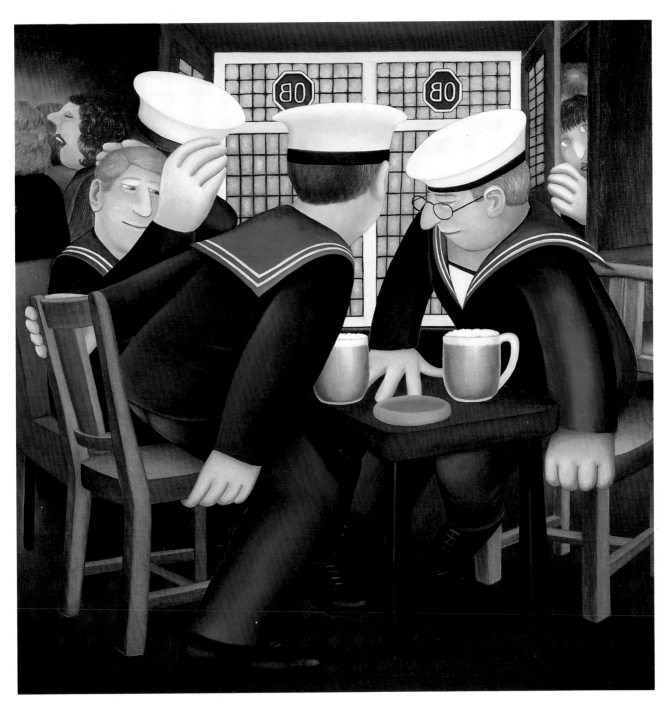

SAILORS

The beer has just been purchased and the sailors are about to sit
down, actions I noted very carefully at the time and most faithfully
reproduced in this picture. I like it when the large foreign training
ships visit Plymouth; sailors from many countries appear in the
streets and pubs, and they look so smart and confident in their
uniforms. I stand about near them until they give me funny looks:
I'm not really trying to pick one up – only draw them!

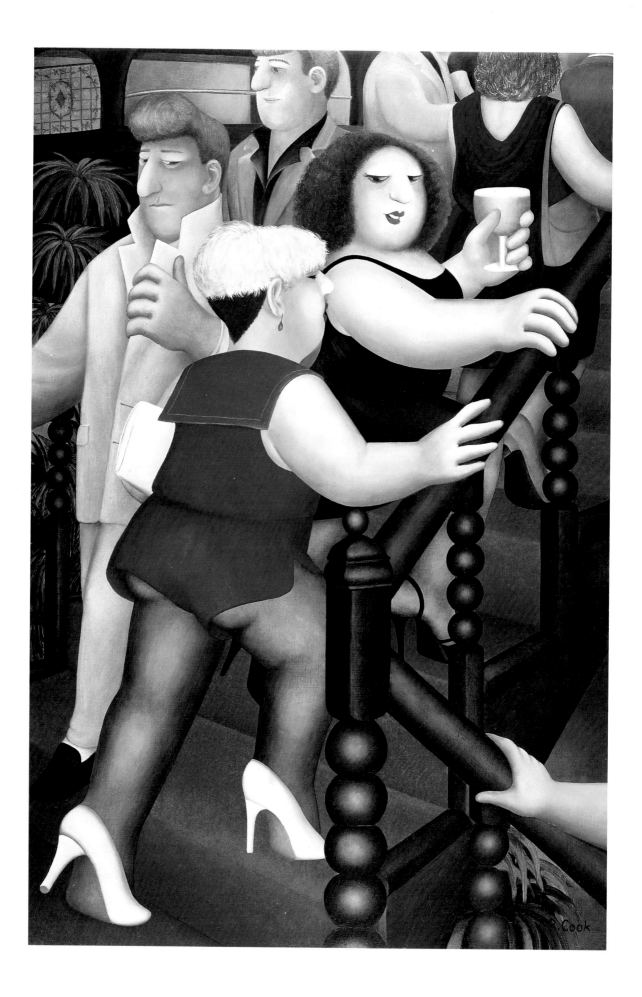

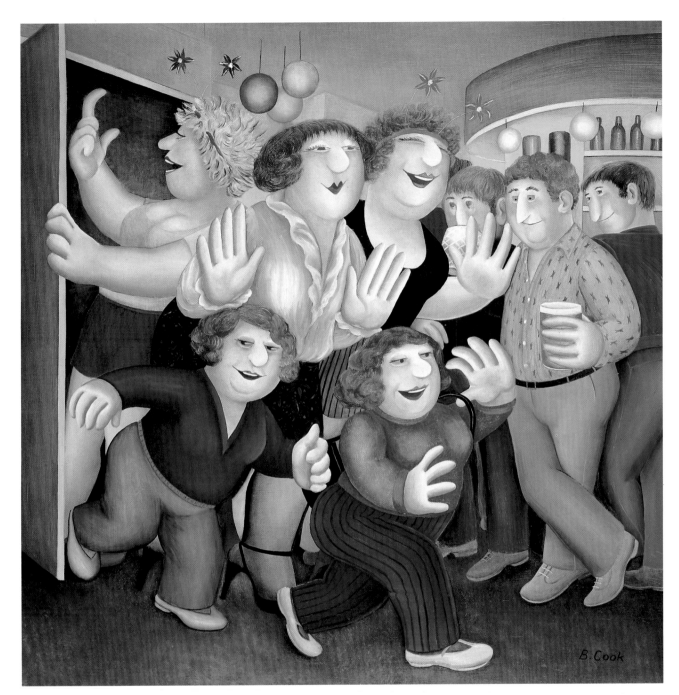

B. Cook

THE STAIRCASE (opposite)

This pub is on two levels with a very nice staircase
centrally placed. As it is always busy and full of young-
sters there is constant movement up and down the stairs,
of people looking for seats, companions, or going to the
upper bar. This is a summer scene and clothing was very
scanty that year, which, I see, I have carefully depicted.
At the bottom of the staircase a comfortable banquette is
the ideal position for an all-round view, if I can manage
to get to it before anyone else does. I like to do staircase
pictures when the opportunity arises as it enables me to
do tall paintings without having too much trouble with
perspective.

GIRLS ON THE TOWN

The door of the pub burst open and this group tumbled
in. Led by two tiny girls, they were getting into the
Christmas spirit, singing, clapping and jiggling the stars
some of them wore in their hair on bandeaus. The men
standing at the bar were rather pleased at the sudden
change in atmosphere, since it had been rather quiet
until then. And it soon was again, for they didn't stay
long – just long enough for me to capture this picture.

THE MANIPULATORS

This picture was painted for the cover of a book called *The Manipulators*, by Winston Fletcher, which I liked a lot and it had plenty of scenes for me to choose from to paint. I decided that this episode in a nightclub would be the best one. The man sitting next to the girl in mauve is my best effort at a Clark Gable lookalike, one of the main characters in the story, and a large photo from a film book was propped in front of me as I drew him. I think I've got the eyebrows at least.

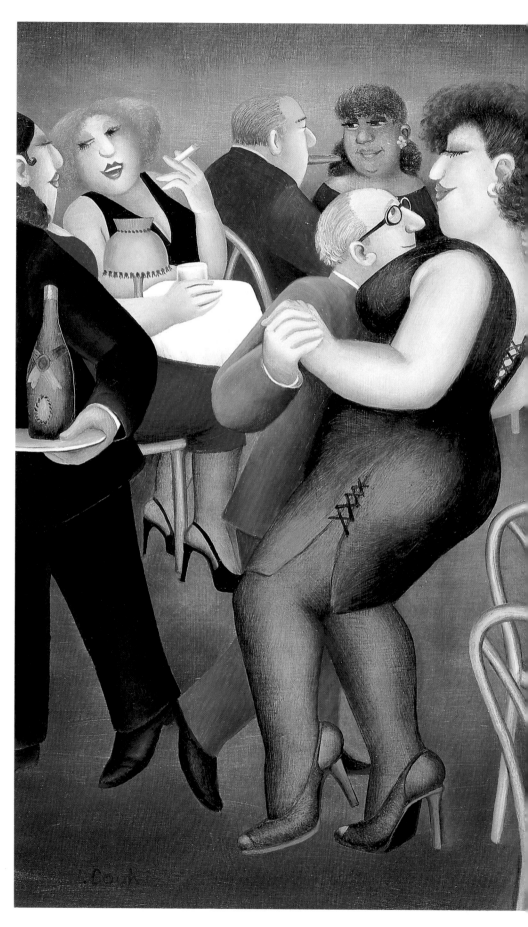

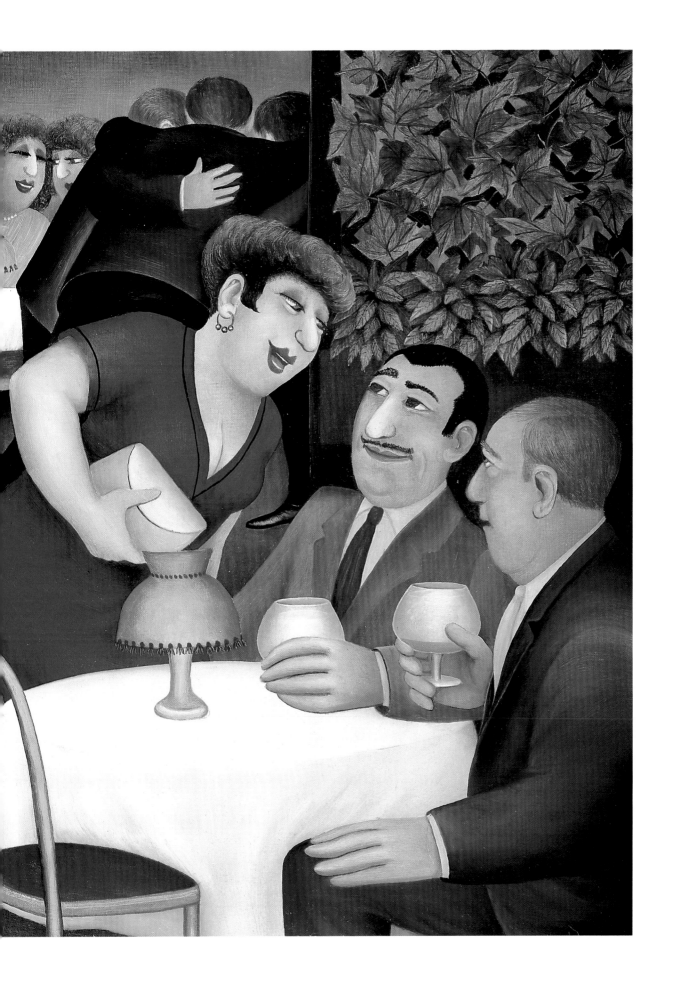

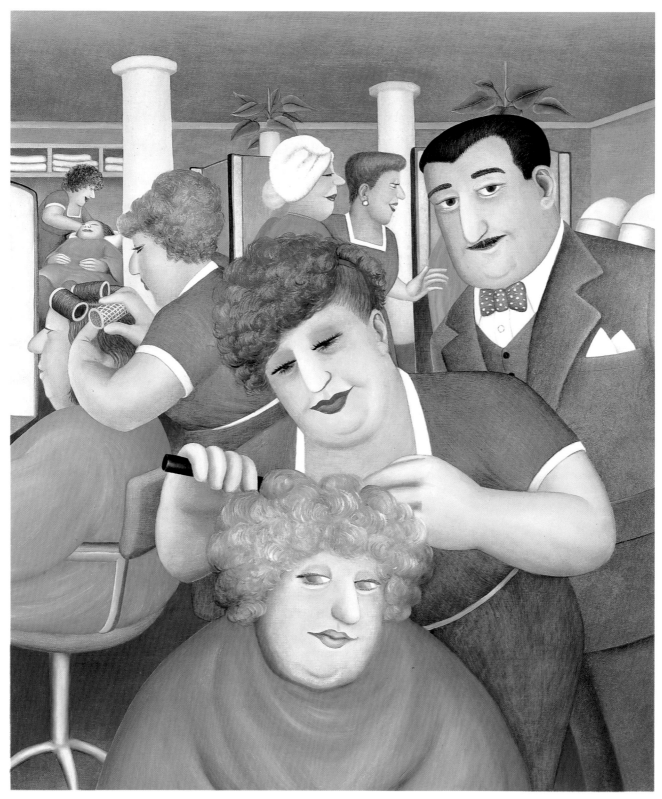

HAIRDRESSING SALON

I'm always interested in busy hands at the hairdressers, and in the various new methods that arrive for teasing and crimping the hair. Shampooing, tinting, cutting and curling are going on all around me, and in the many mirrors I see reflections of the smart hairstyles gradually emerging from the capable hands of the assistants. There is only one gentleman in this salon – the head of the department – and he sometimes walks through to see that everything goes well, which I'm glad to say it does.

MOP HEADS

In a bar near here, some time ago, the barmaids used to wear little red
T-shirts and all had hair teased out to extravagant heights. In fact the
teasing and arranging of the various styles would often be in progress
as we entered the bar early in the evening, the girls taking turns with
the tongs and curry-comb. I did not think I could do justice to the hair
using only paint, and decided to unravel a cotton mop-head to achieve
sufficient volume. Days later, I was still covered in sticky fluff from
trying to attach this bulk to the heads in the picture, with not quite
the effect I had hoped to achieve. Since then it has hung in a dark
corner, warning me to be cautious about future brilliant ideas.

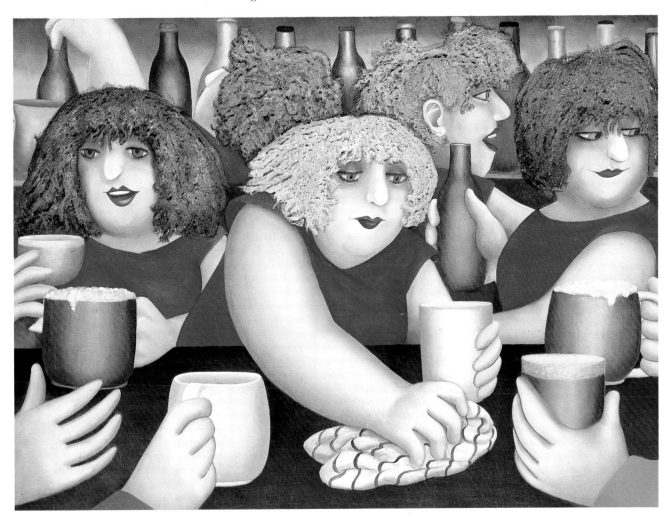

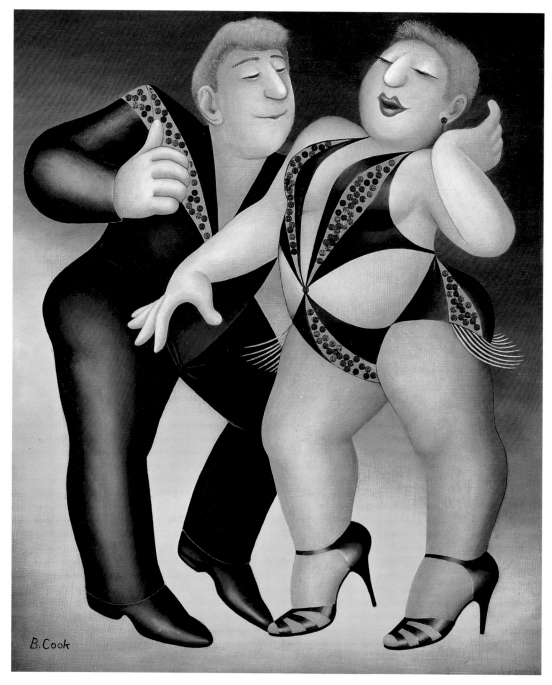

CHA CHA CHA

Another view of 'Come Dancing'. The costumes are so exotic that I am always tempted to reproduce them, and I decided that these ones should have stuck-on sequins for added lustre. Fringes on the dresses were fashionable again and I would have liked those in the picture to be more extravagant, but in my paintings I often have to make do with what appears instead of the sumptuous image I had hoped to capture. The popular hairstyle for this series was very short with a tiny tuft jutting out over the forehead and I rather wish I hadn't noticed this, as I laboured long to get the effect. Ginger hair is my favourite and it is always likely to appear if there is no particular reason for another colour.

THE DANCER

This is a happy man. He couldn't resist the music and frequently put down his glass to dance a little more. Sometimes his friend continued her conversation with the others there and sometimes she watched him, but he didn't really mind either way. He danced off and on for the two hours or so I was in the pub, and I daresay all the way home, too. Now he dances in a picture, forever seduced by the rhythm of the music.

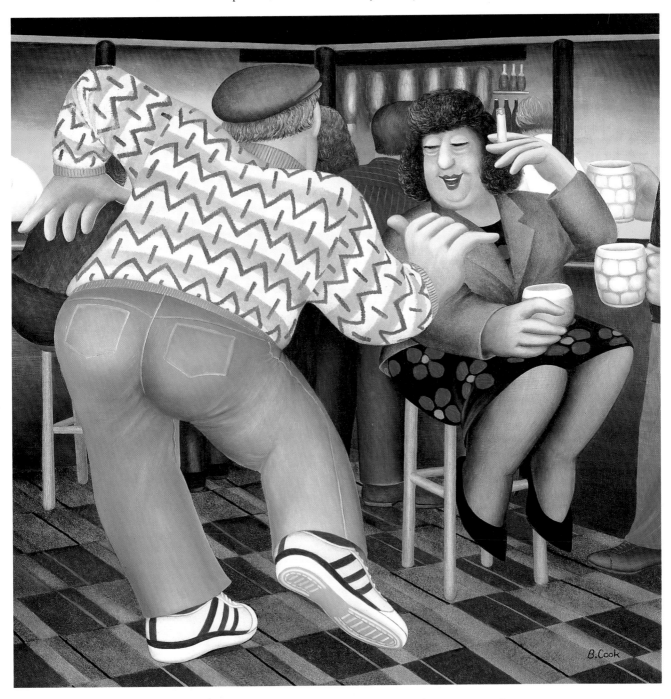

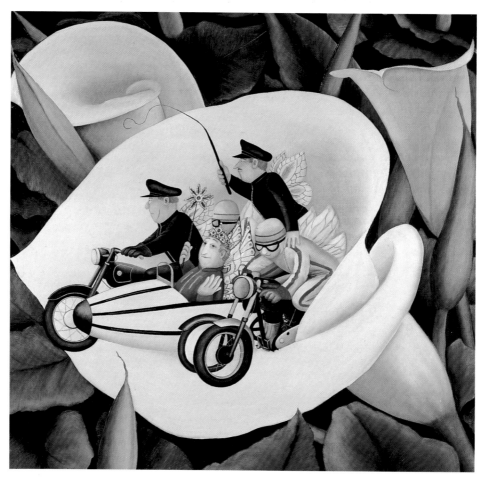

QUEEN OF THE FAIRIES

My flower fairies, and there have been quite a few, are usually sturdy
girls dressed in petals busily engaged in appropriate fairy business.
A huge white lily growing in the garden gave me the idea for this
picture. As a change the fairies would be modern, dress in leather
clothes and ride bikes – something I wish I had enough nerve to do
myself. In a picture of antique motorbikes I found a smart black and
white sidecar, which was just the right thing for a Fairy Queen to ride
in in comfort. Now they can speed off by wheel and wing to a very
important engagement in the vegetable garden (not yet illustrated).

A friendly Inspector from the Plymouth police force told me of a little
episode that occurred while he was controlling the traffic during the
Plymouth Carnival. Having marched, sung and cheered their way all
round Plymouth, one of the performers was overcome by fatigue, and
he kindly offered her a short lift on the bonnet of his car. The carnival
passes in front of our house and I have always been surprised at the
stamina of the people involved – youngsters dancing, bands playing,
small children twirling batons; they have a long way to go, some-
times in dreadful weather. It's all done in the best of good spirits, and
I liked the story so much I decided to see if I could paint it. Our small
dog Minnie makes an appearance, too, sitting quietly in a pram with a
funny hat on – something she wouldn't *dream* of doing in real life.

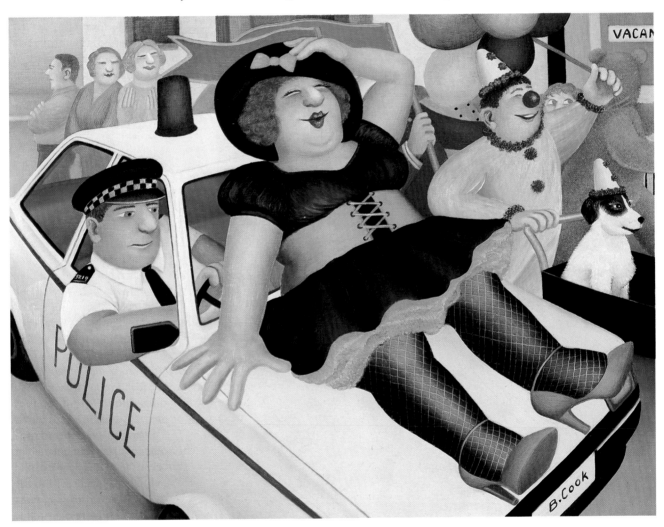

TWINKLETOES

This is a Christmas card I painted for my husband. We are both avid fans of 'Come Dancing', especially the Latin American, and have noticed that the outfits for this have grown scantier as the years have gone by. What lovely figures the girls have, and how on earth do they keep the costumes on? We'd really like one of these each and have discussed what designs we'd choose while watching the twirling bodies.

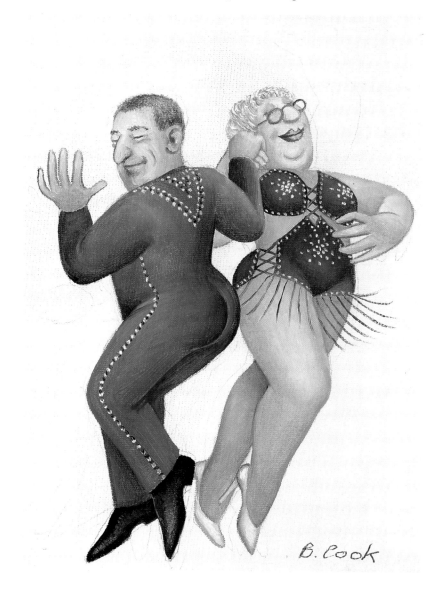

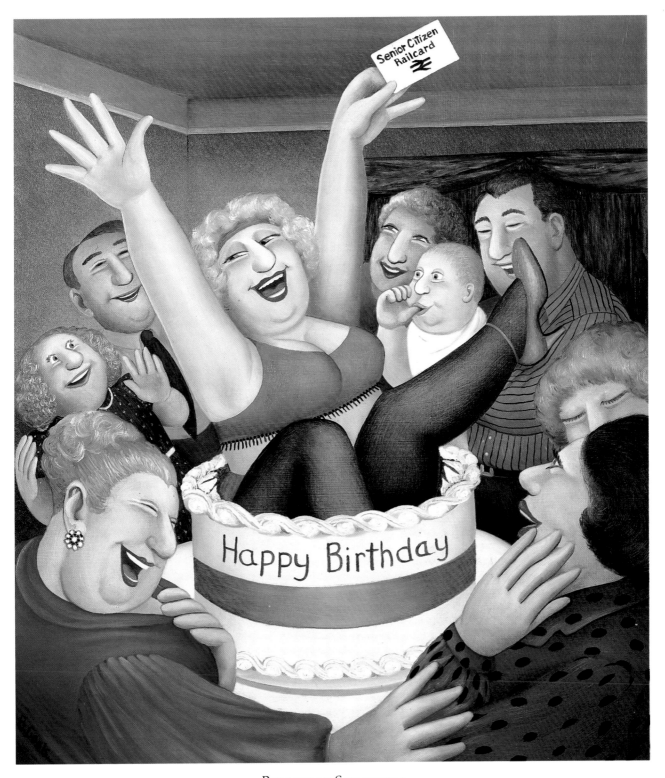

BIRTHDAY SURPRISES

Grandma's railcard has certainly enabled her to give a very big surprise indeed to the happy family. I really enjoyed doing this painting for British Rail, since I have one of these cards myself, and the suggestion that she should emerge from a cake appealed to me enormously. The grandmothers I know are very trendy these days and buy their clothes, like me, in the teenage departments. It's not easy to squeeze the mature figure into a tiny teenage size, I can tell you. But this particular granny is wearing a comfortable green two-piece with shoes to match, designed by me as suitable gear for the fun-loving older woman – travelling by cake.

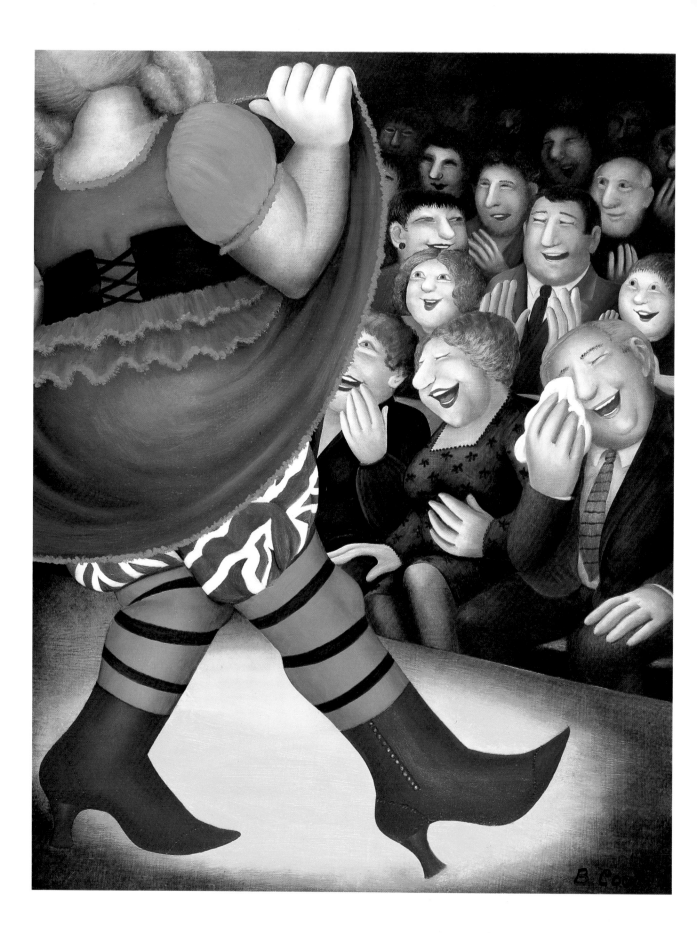

Pantomime Dame (opposite)

Here is an audience thoroughly enjoying the antics of the Dame at the Christmas pantomime. It was Danny La Rue being very funny and he is shown from the back, with just a glimpse of knicker, so that I could paint the rows of happy faces. Putting him in the spotlight took some serious thinking on my part: I settled for a yellow circle round his feet and hope you think this gives the desired effect. I like painting audiences, as I enjoy it so much when they laugh.

The British Eight

Here is the British eight, straining every muscle in their endeavour to win the race. This picture was inspired by a small newspaper cutting and as it was a sideways view I had the task of re-arranging them like this so I could better show the effort involved. The water was difficult but I think I've made rather a good job of it. For one who does not participate in any way I show an unusual interest in sport. I don't really mind which side is winning so it must be the movement of the bodies that appeals and I've painted boxing, wrestling, soccer, bowling and roller-skating as well as these rowers.

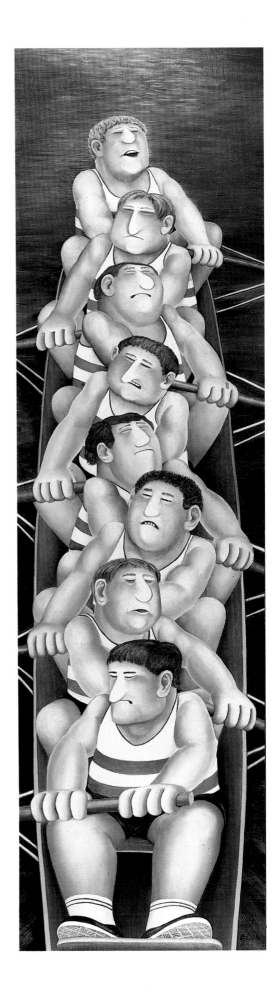

COUNTRY MUSIC

How absorbed in their music these girls are, playing away in the serene summer countryside. I rather like musical instruments, and especially the hands which play them. I learned how a cellist would sit, and the correct place for the fingers, from a newspaper cutting I have of Paul Tortelier. The violin I found in a book from the lending library, a most useful place for all sorts of things I suddenly decide I need to draw. But the pianiste may not be on the same musical wavelength as the other two, for she is taken from a drawing I did of a jazz player energetically attacking a honky-tonk piano, which I changed to something rather more upmarket for this scene. A Steinway perhaps.

VIRGIN AND CHILD *(opposite)*

A friend asked me if I could paint a nativity scene to celebrate an anniversary and this is what appeared. It is based on a photograph I have of my mother firmly clasping to her hip an enormous, sprawling baby – me. The size of the child she is trying to hold up and the clothes have always given this photo great appeal to me. A similar one of my husband proudly clasped to his mother's bosom shows a baby of rather more usual proportions, and easier to hold in a steady pose for the photographer. A few more details were needed to make a suitable painting and so I added some golden curls, a roguish smile and a bluebird. I like nativity scenes and old religious paintings and look for them in galleries, which is where I found out how to do the haloes.

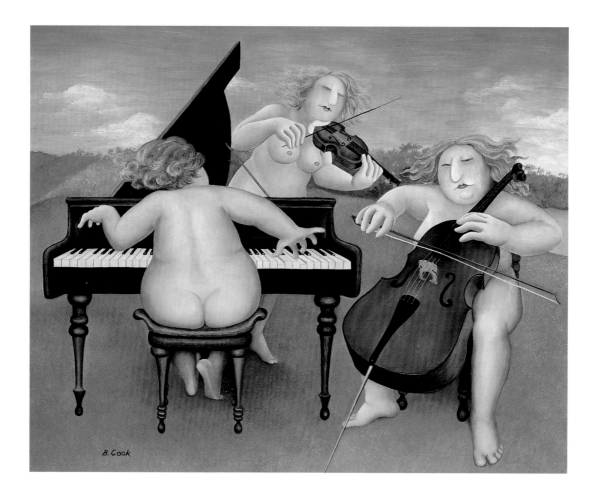

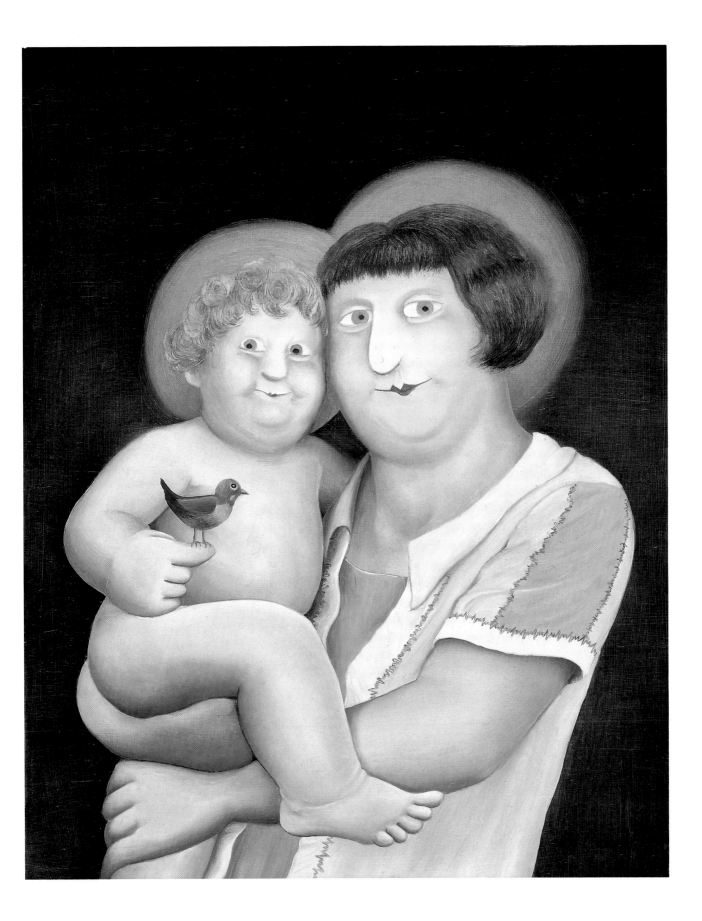

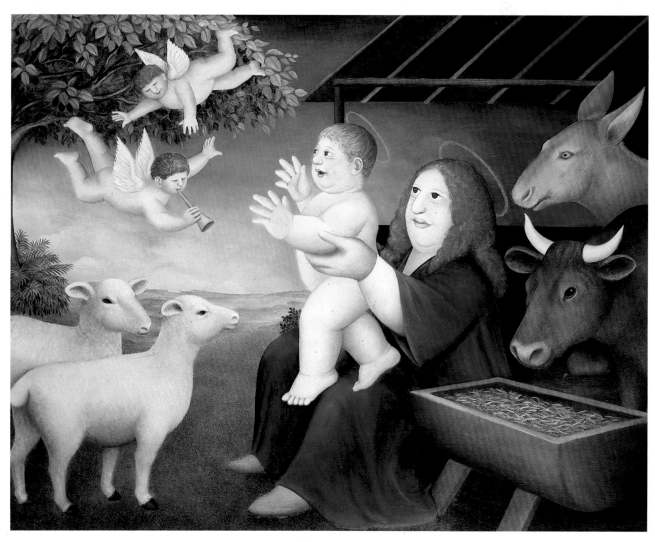

NATIVITY

Beryl Cook's paintings are available from
Portal Gallery Ltd, London

Limited edition prints are available from
The Alexander Gallery, Bristol

Greetings cards and calendars are published by
Gallery Five Ltd, London

Original serigraphs and lithographs are published by
Flanagan Graphics Inc., Haverford, PA, USA